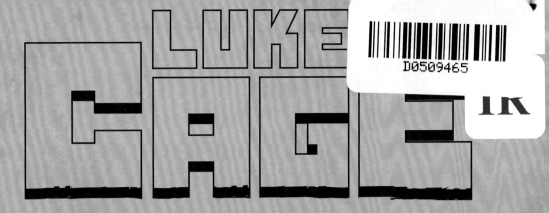

While imprisoned for a crime he did not commit, LUKE CAGE was subjected to medical experiments that gave him superhuman strength and bulletproof skin. Once free, he used his abilities to become a HERO FOR HIRE, protecting people who had nowhere else to turn. His mission has taken him to Wakanda, the Savage Land, even Avengers Mansion, but Luke has never forgotten where he came from.

Recently, Luke went to New Orleans for the funeral of the man who gave him his powers, DR. NOAH BURSTEIN. However, it turned out Burstein wasn't dead. Luke discovered the secret of Burstein's disappearance, and all hell broke loose. Now, the dust has settled, and it's time for Luke to go home.

CAGED!

DAVID F. WALKER
WRITER

GUILLERMO SANNA
ARTIST

MARCIO MENYZ
COLOR ARTIST

RAHZZAH
COVER ARTIST

VC's JOE SABINO
LETTERER

KATHLEEN WISNESKI
ASSISTANT EDITOR

MARK BASSO
ASSOCIATE EDITOR

JAKE THOMAS
EDITOR

COLLECTION EDITOR **MARK D. BEAZLEY**
ASSISTANT EDITOR **CAITLIN O'CONNELL**
ASSOCIATE MANAGING EDITOR **KATERI WOODY**
SENIOR EDITOR, SPECIAL PROJECTS **JENNIFER GRÜNWALD**

VP PRODUCTION & SPECIAL PROJECTS **JEFF YOUNGQUIST**
SVP PRINT, SALES & MARKETING **DAVID GABRIEL**
BOOK DESIGNER **ADAM DEL RE**

EDITOR IN CHIEF **C.B. CEBULSKI**
CHIEF CREATIVE OFFICER **JOE QUESADA**
PRESIDENT **DAN BUCKLEY**
EXECUTIVE PRODUCER **ALAN FINE**

LUKE CAGE VOL. 2: CAGED! Contains material originally published in magazine form as LUKE CAGE #166-170. First printing 2018. ISBN 978-1-302-90779-2. Published by MARVEL WORLDWIDE, INC., a subsidiary of MARVEL ENTERTAINMENT, LLC. OFFICE OF PUBLICATION: 135 West 50th Street, New York, NY 10020. Copyright © 2018 MARVEL No similarity between any of the names, characters, persons, and/or institutions in this magazine with those of any living or dead person or institution is intended, and any such similarity which may exist is purely coincidental. **Printed in Canada.** DAN BUCKLEY, President, Marvel Entertainment; JOHN NEE, Publisher; JOE QUESADA, Chief Creative Officer; TOM BREVOORT, SVP of Publishing; DAVID BOGART, SVP of Business Affairs & Operations, Publishing & Partnership; DAVID GABRIEL, SVP of Sales & Marketing, Publishing; JEFF YOUNGQUIST, VP of Production & Special Projects; DAN CARR, Executive Director of Publishing Technology; ALEX MORALES, Director of Publishing Operations; SUSAN CRESPI, Production Manager; STAN LEE, Chairman Emeritus. For information regarding advertising in Marvel Comics or on Marvel.com, please contact Vit DeBellis, Custom Solutions & Integrated Advertising Manager, at vdebellis@marvel.com. For Marvel subscription inquiries, please call 888-511-5480. **Manufactured between 2/23/2018 and 3/27/2018** by **SOLISCO PRINTERS, SCOTT, QC, CANADA.**

0987654321

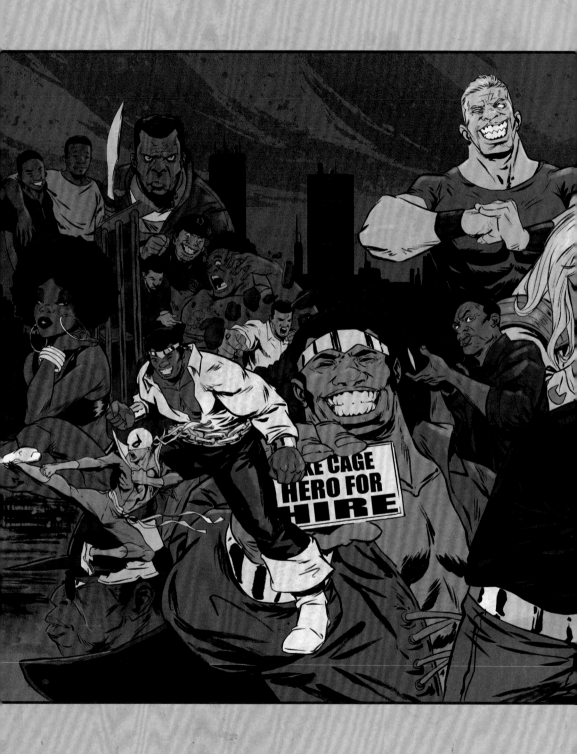

#166-168 CONNECTING VARIANTS BY
SANFORD GREEN & **RICO RENZI**

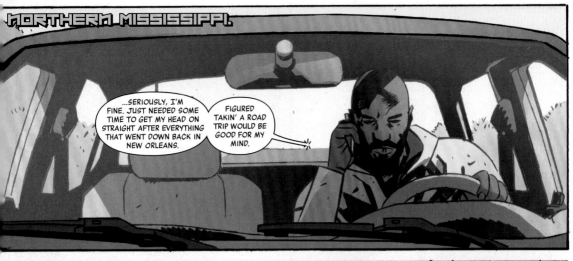

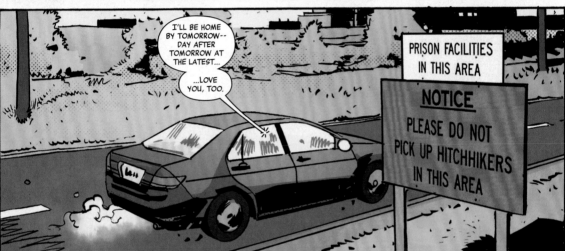

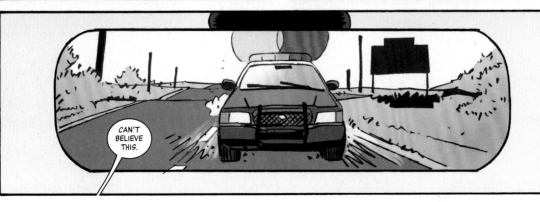

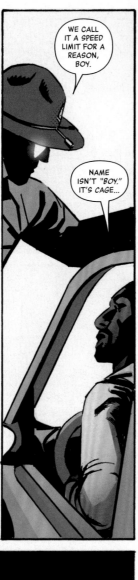

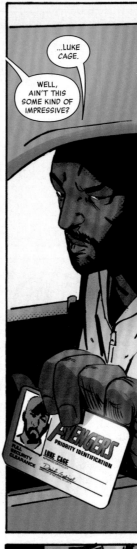

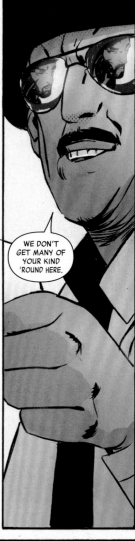

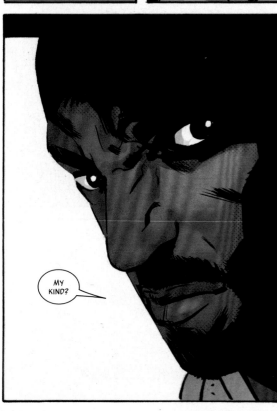

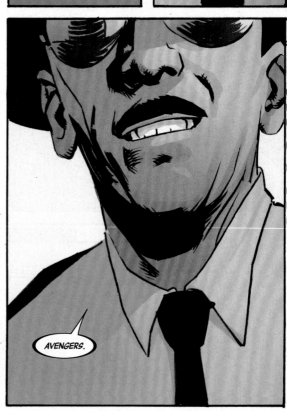

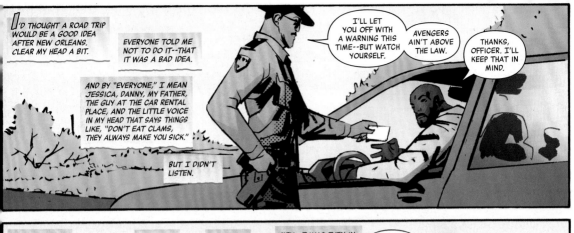

I'D THOUGHT A ROAD TRIP WOULD BE A GOOD IDEA AFTER NEW ORLEANS. CLEAR MY HEAD A BIT.

EVERYONE TOLD ME NOT TO DO IT--THAT IT WAS A BAD IDEA.

AND BY "EVERYONE," I MEAN JESSICA, DANNY, MY FATHER, THE GUY AT THE CAR RENTAL PLACE, AND THE LITTLE VOICE IN MY HEAD THAT SAYS THINGS LIKE, "DON'T EAT CLAMS, THEY ALWAYS MAKE YOU SICK."

BUT I DIDN'T LISTEN.

I'LL LET YOU OFF WITH A WARNING THIS TIME--BUT WATCH YOURSELF.

AVENGERS AIN'T ABOVE THE LAW.

THANKS, OFFICER. I'LL KEEP THAT IN MIND.

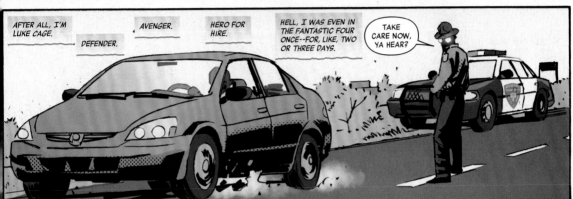

AFTER ALL, I'M LUKE CAGE.

DEFENDER.

AVENGER.

HERO FOR HIRE.

HELL, I WAS EVEN IN THE FANTASTIC FOUR ONCE--FOR, LIKE, TWO OR THREE DAYS.

TAKE CARE NOW, YA HEAR?

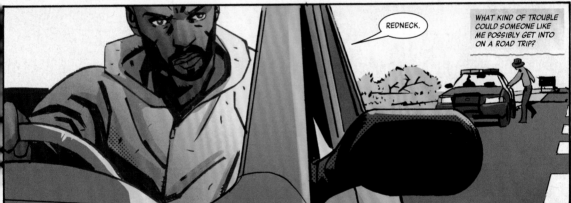

REDNECK.

WHAT KIND OF TROUBLE COULD SOMEONE LIKE ME POSSIBLY GET INTO ON A ROAD TRIP?

THIS IS SEVEN CARRIE THREE, GONNA NEED YOU TO LET THE BIG BOSS KNOW...

...WE GOT A POTENTIAL PROBLEM ON OUR HANDS.

REPEAT-- WE MAY HAVE OURSELVES A PROBLEM.

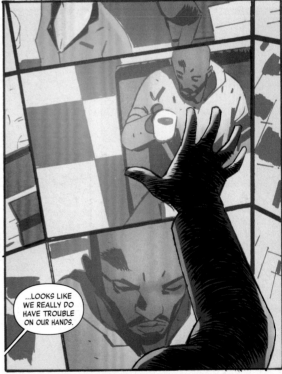

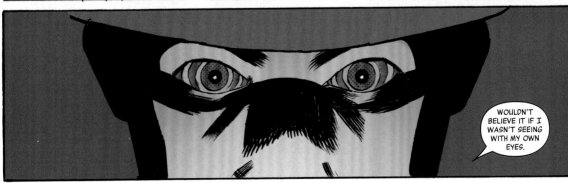

CAN I GET YOU ANYTHING ELSE?

JUST THE BILL. GOTTA GET BACK ON THE ROAD--GET BACK HOME.

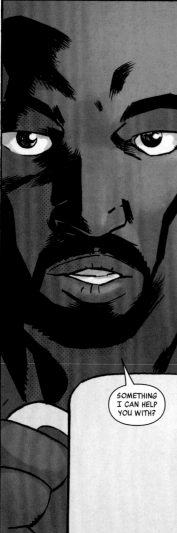

SOMETHING I CAN HELP YOU WITH?

I HATE TO BOTHER YOU... BUT I KNOW YOU.

YOU'RE LUKE CAGE, RIGHT?

AVENGERS. HEROES FOR HIRE--YOU HELP PEOPLE?

WHAT SEEMS TO BE THE PROBLEM?

I DON'T KNOW HOW TO EXPLAIN IT.

OKAY...

IT'S JUST... WELL...

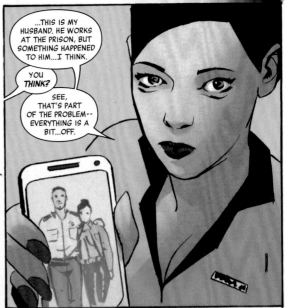

...THIS IS MY HUSBAND. HE WORKS AT THE PRISON, BUT SOMETHING HAPPENED TO HIM...I THINK.

YOU *THINK*?

SEE, THAT'S PART OF THE PROBLEM-- EVERYTHING IS A BIT...OFF.

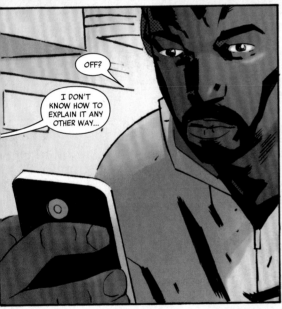

OFF?

I DON'T KNOW HOW TO EXPLAIN IT ANY OTHER WAY...

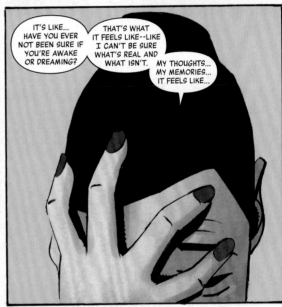

IT'S LIKE... HAVE YOU EVER NOT BEEN SURE IF YOU'RE AWAKE OR DREAMING?

THAT'S WHAT IT FEELS LIKE--LIKE I CAN'T BE SURE WHAT'S REAL AND WHAT ISN'T.

MY THOUGHTS... MY MEMORIES... IT FEELS LIKE...

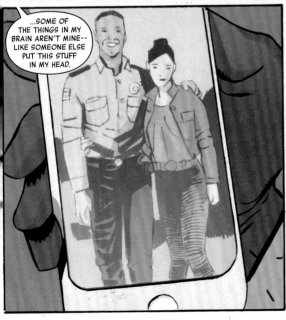

...SOME OF THE THINGS IN MY BRAIN AREN'T MINE-- LIKE SOMEONE ELSE PUT THIS STUFF IN MY HEAD.

OH, NO...

WHAT? WHAT'S THE MATTER?

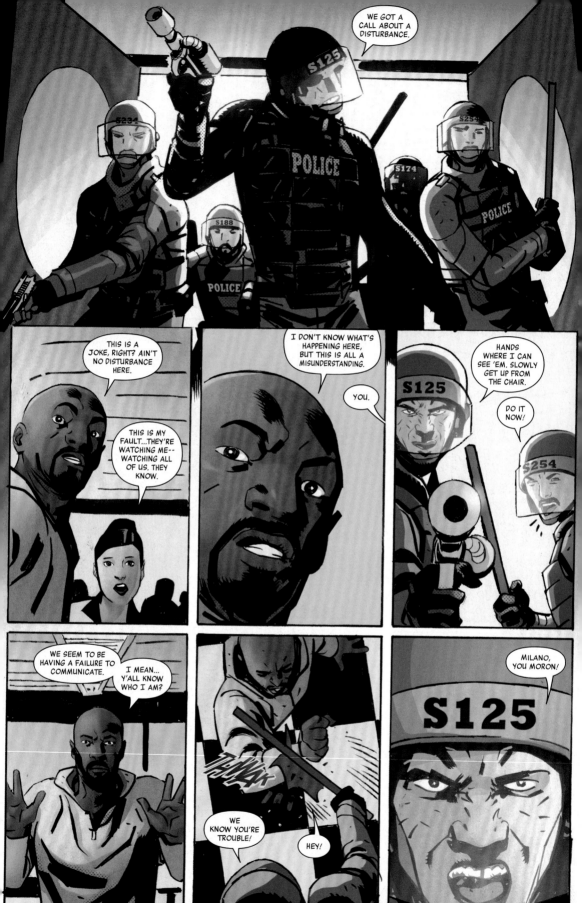

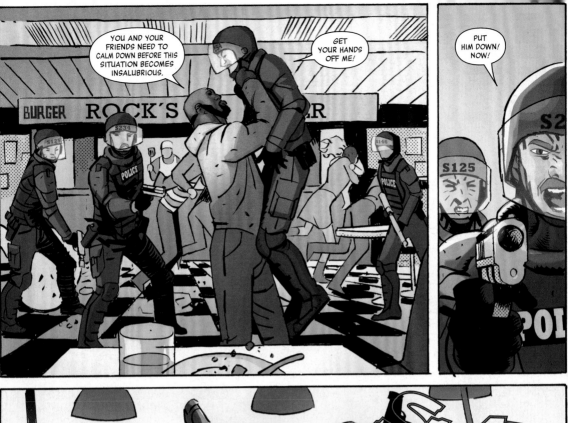

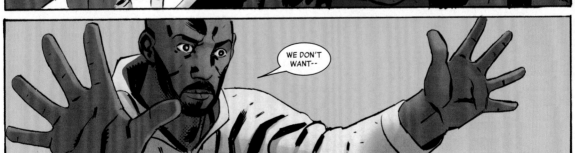
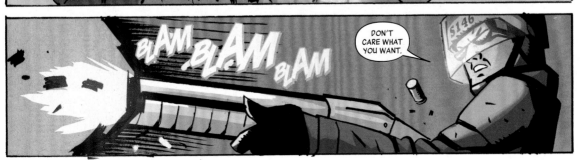

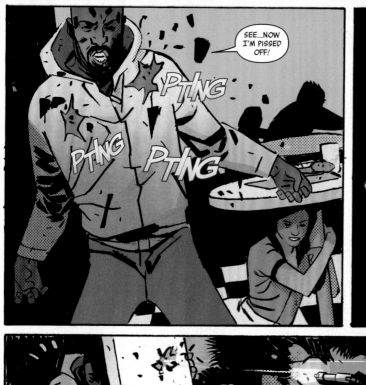
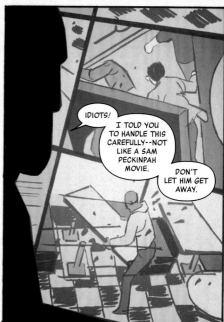
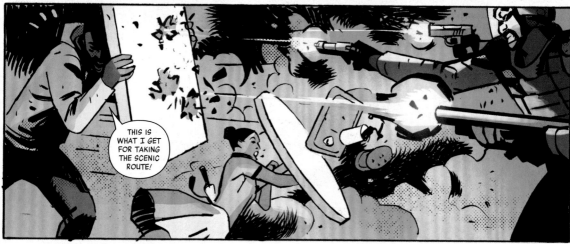
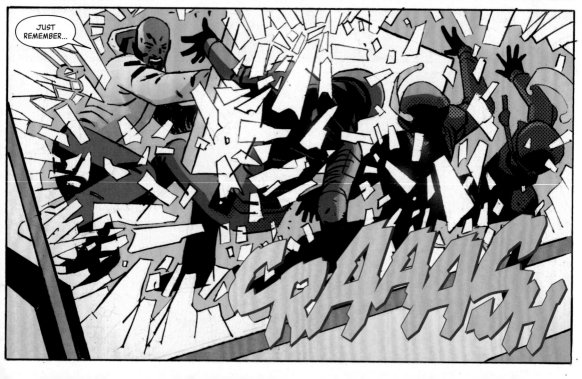

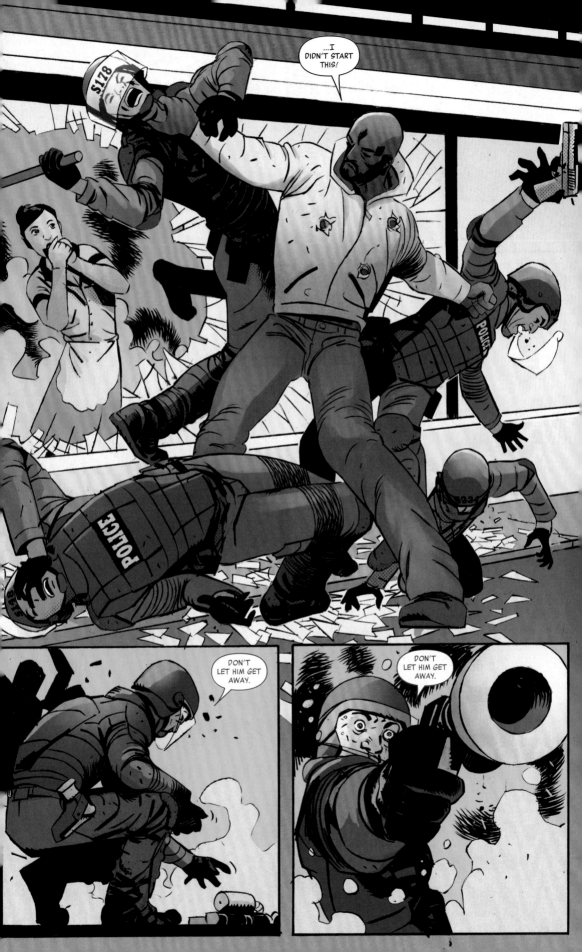

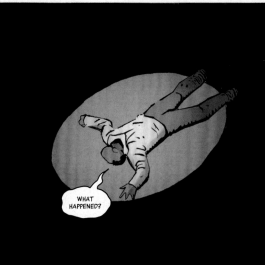

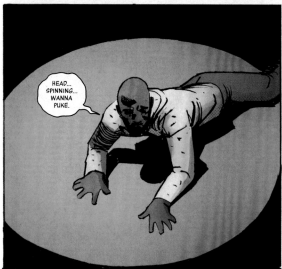

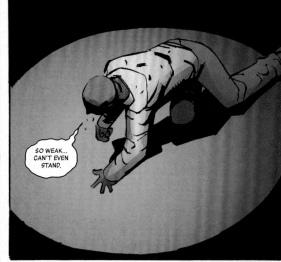

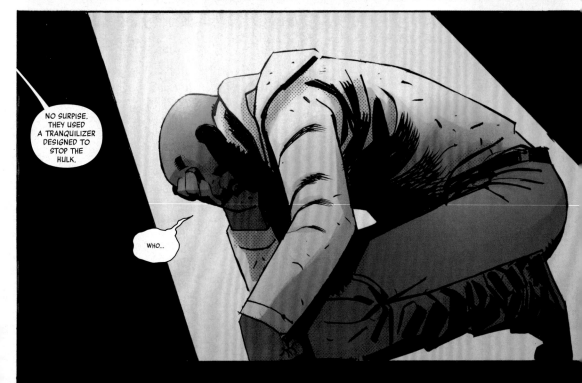

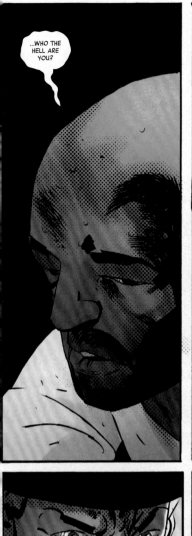

...WHO THE HELL ARE YOU?

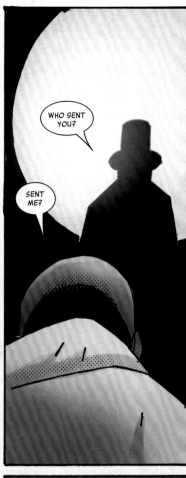

WHO SENT YOU?

SENT ME?

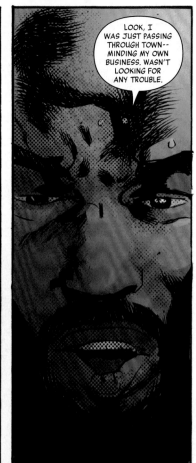

LOOK, I WAS JUST PASSING THROUGH TOWN-- MINDING MY OWN BUSINESS. WASN'T LOOKING FOR ANY TROUBLE.

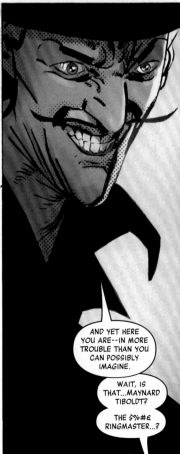

AND YET HERE YOU ARE--IN MORE TROUBLE THAN YOU CAN POSSIBLY IMAGINE.

WAIT, IS THAT...MAYNARD TIBOLDT?

THE $%#€ RINGMASTER...?

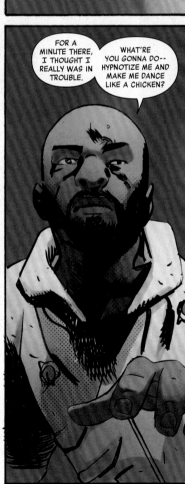

FOR A MINUTE THERE, I REALLY WAS IN TROUBLE.

WHAT'RE YOU GONNA DO-- HYPNOTIZE ME AND MAKE ME DANCE LIKE A CHICKEN?

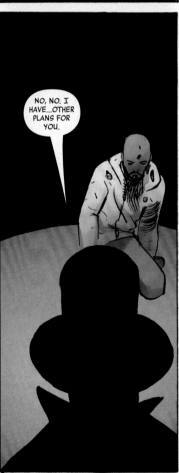

NO, NO. I HAVE...OTHER PLANS FOR YOU.

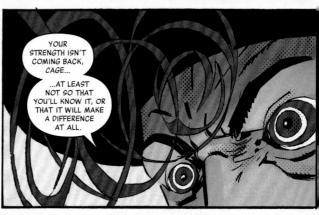

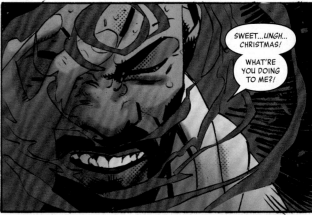

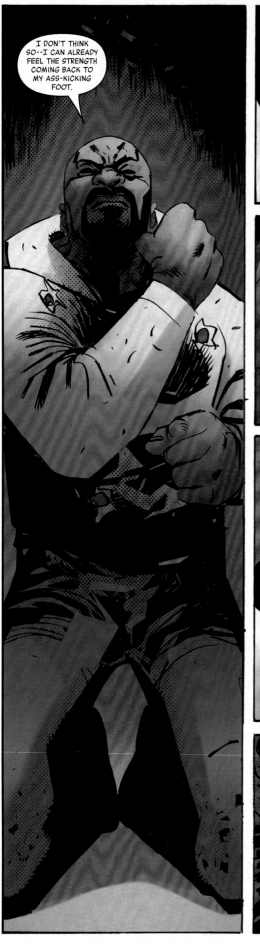

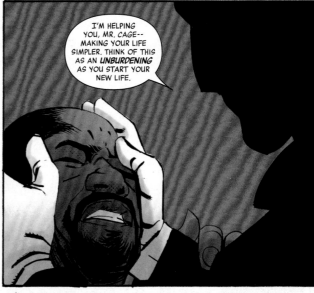

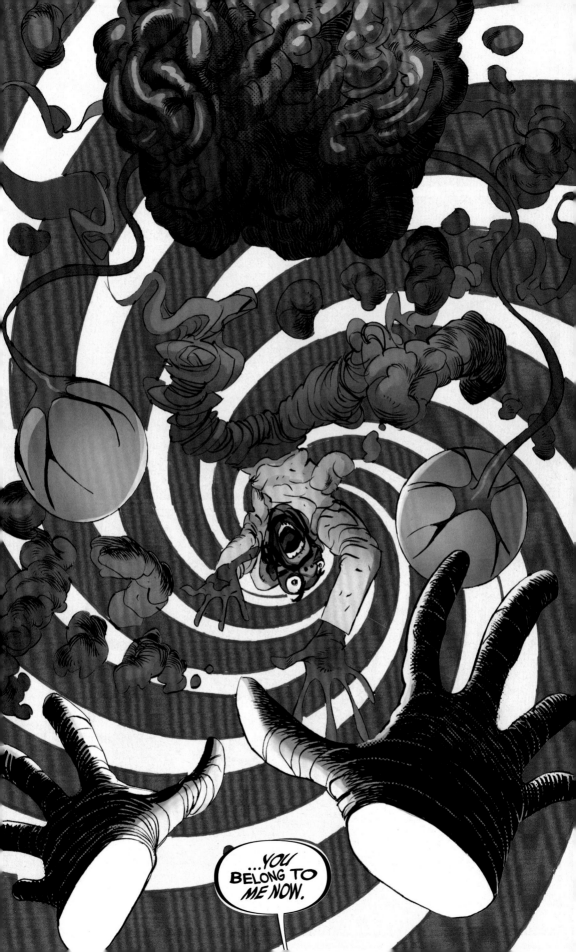

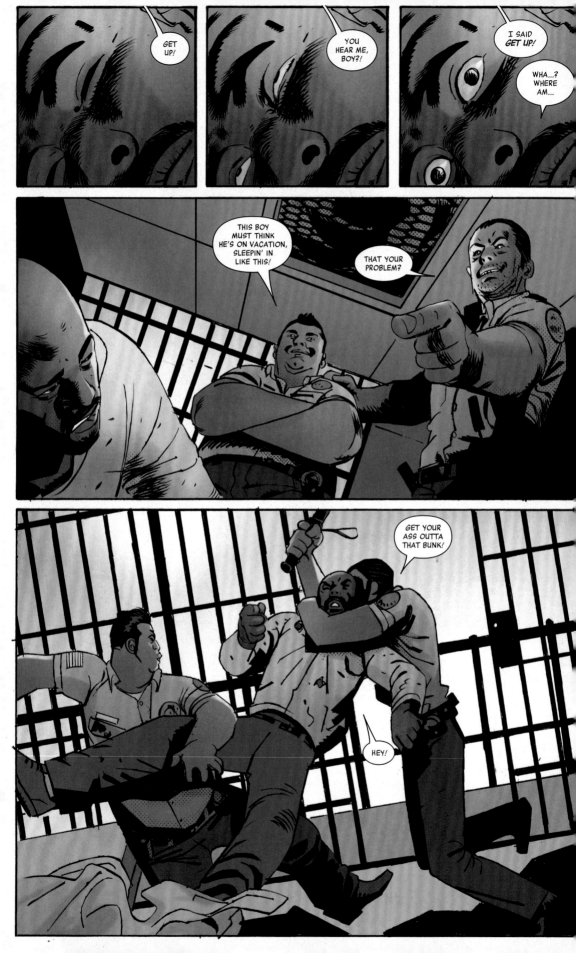

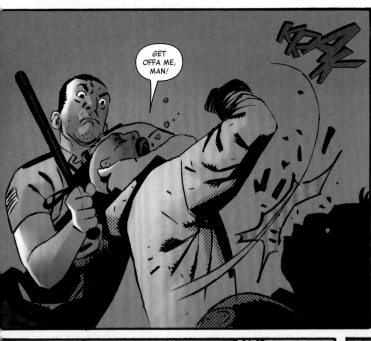

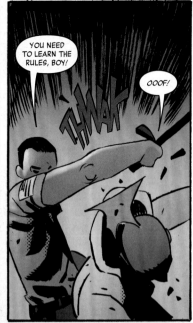

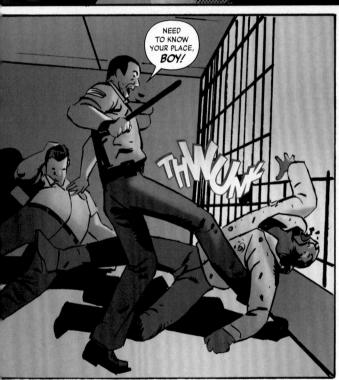

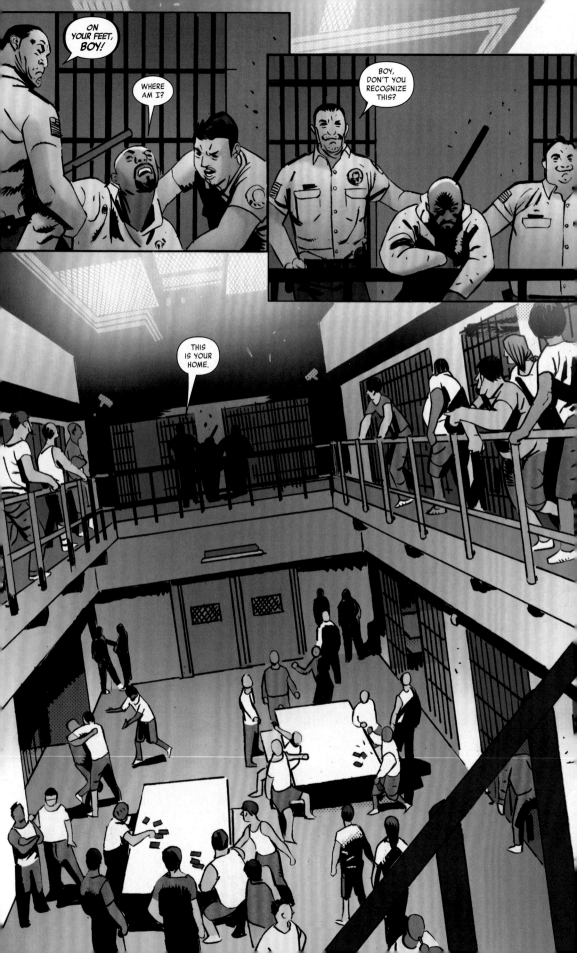

MARVEL LEGACY

MARVEL COMICS GROUP

166 VARIANT EDITION

LUKE CAGE

HERO FOR HIRE

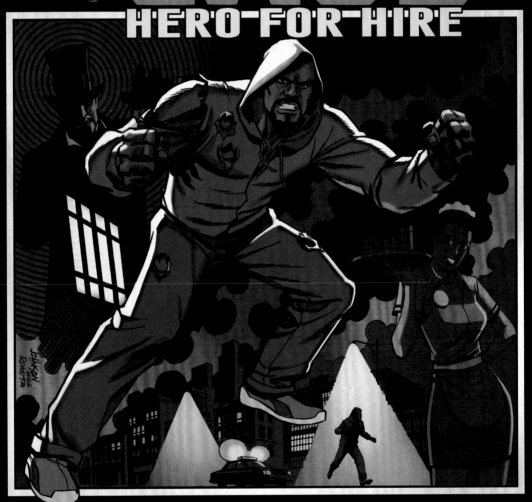

SENSATIONAL ACTION!!!

#166 HOMAGE VARIANT BY
DAVE JOHNSON

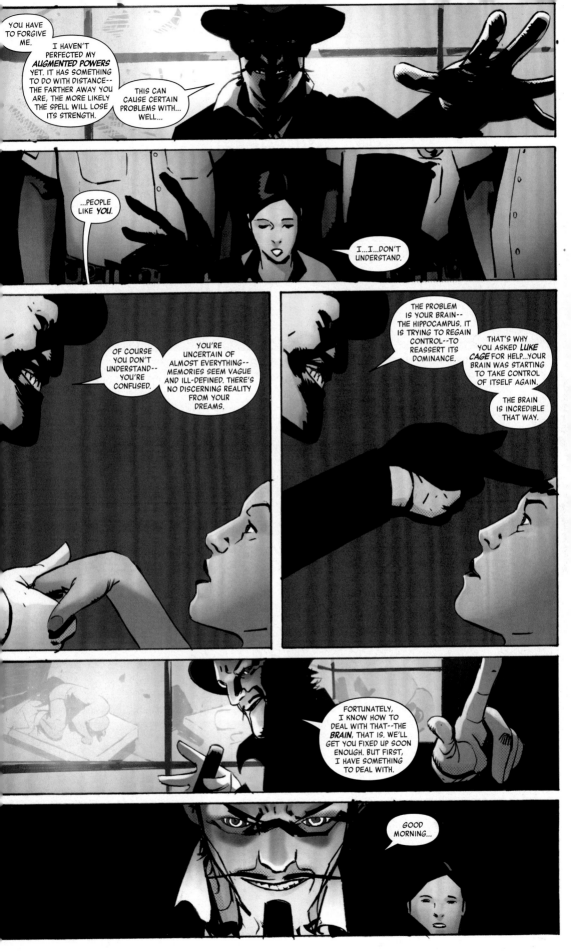

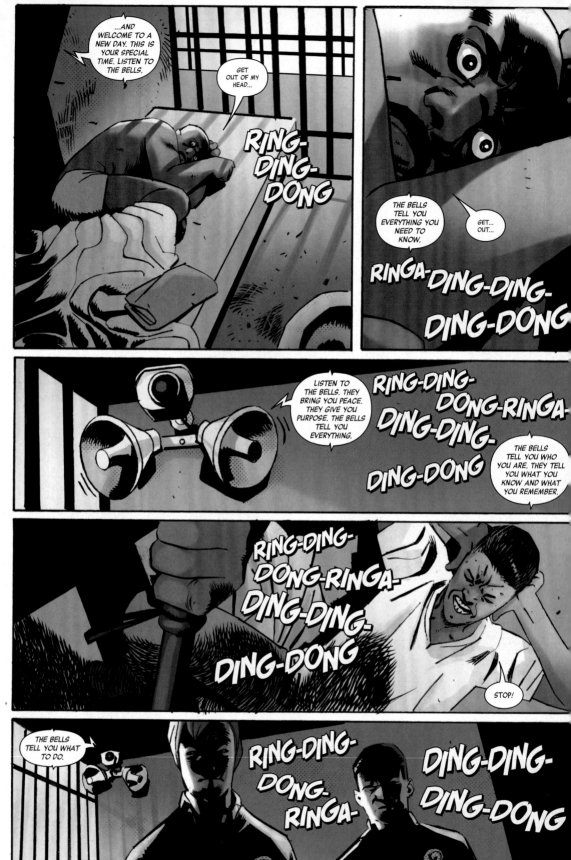

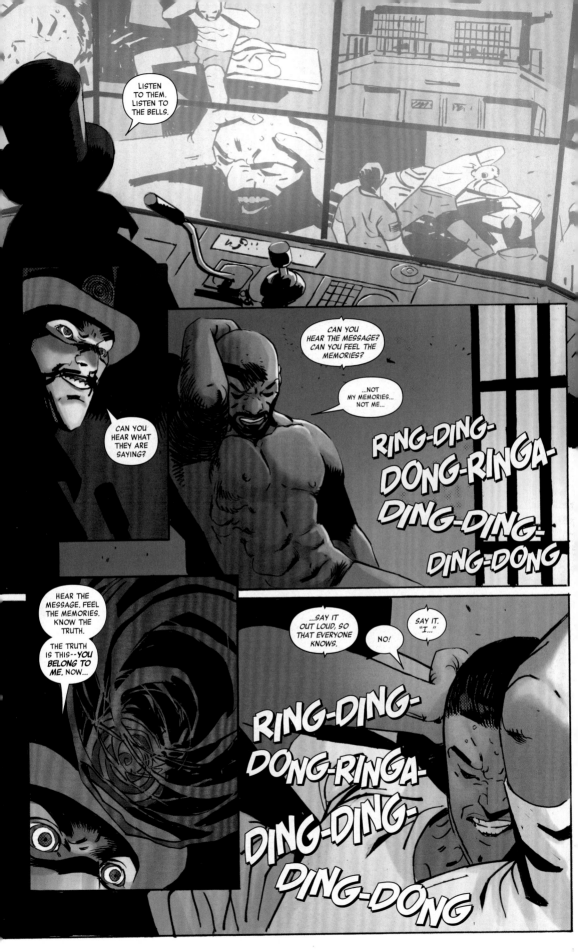

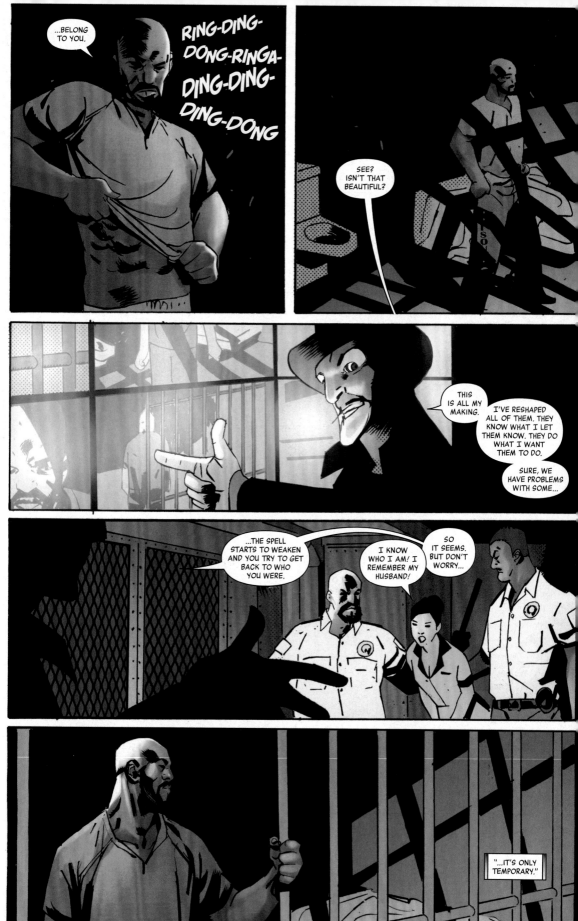

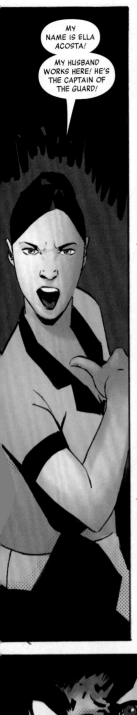

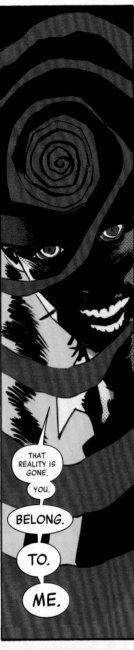

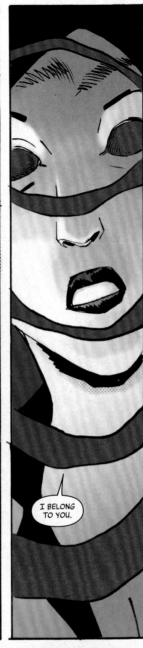

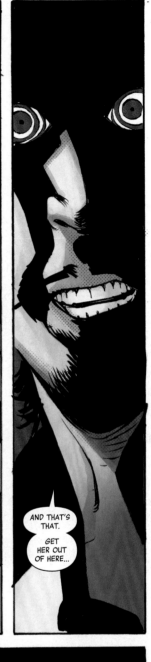

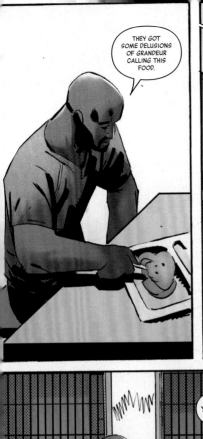

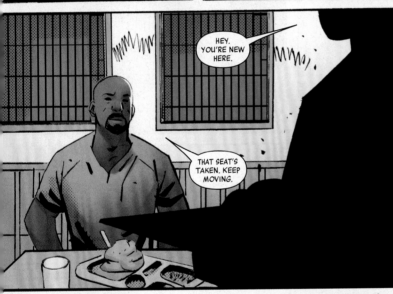

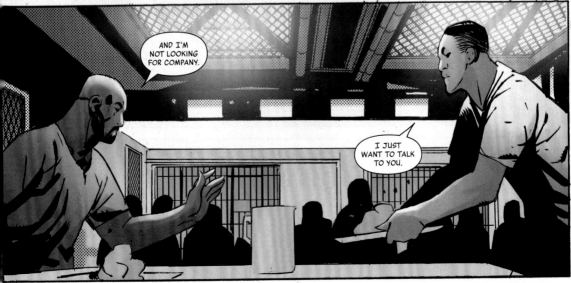

LOOK AT THIS--WHAT KIND OF TROUBLE ARE THE TWO OF YOU GETTING INTO?

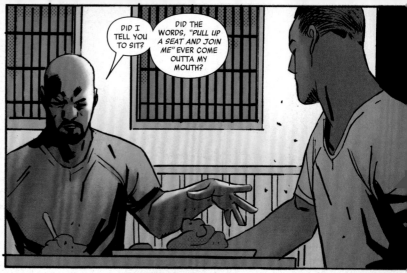

DID I TELL YOU TO SIT?

DID THE WORDS, "PULL UP A SEAT AND JOIN ME" EVER COME OUTTA MY MOUTH?

YOU NAUGHTY BOYS-- I'VE TOLD ALL OF YOU THE RULES.

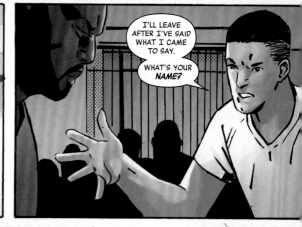

I'LL LEAVE AFTER I'VE SAID WHAT I CAME TO SAY.

WHAT'S YOUR NAME?

OH, DEAR. LET'S GIVE EVERYONE A LITTLE REMINDER.

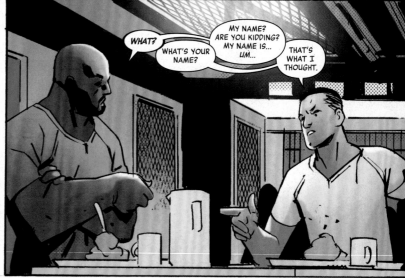

WHAT?

WHAT'S YOUR NAME?

MY NAME? ARE YOU KIDDING? MY NAME IS... UM...

THAT'S WHAT I THOUGHT.

THERE'S SOMETHING GOING ON HERE. ASK ANYONE THEIR NAME--THEY DON'T KNOW IT. THEIR LIVES OUTSIDE, WHAT THEY DID--NO ONE REMEMBERS.

SOMETHING-- OR SOMEONE-- IS MESSING WITH OUR BRAINS.

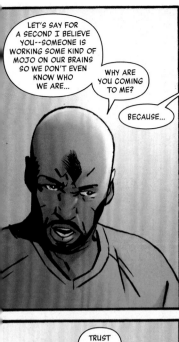

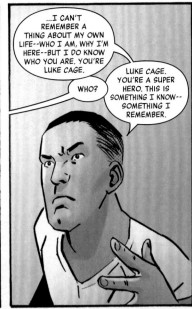

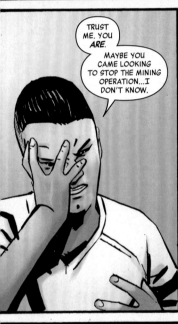

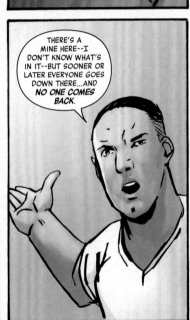

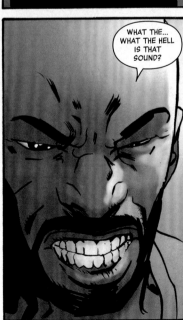

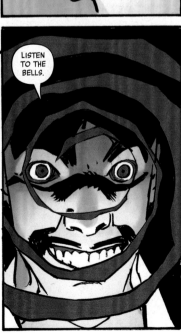

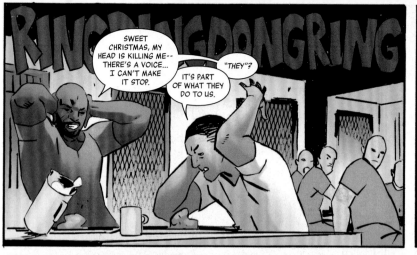

RINGDINGDONGRING

SWEET CHRISTMAS, MY HEAD IS KILLING ME-- THERE'S A VOICE... I CAN'T MAKE IT STOP.

"THEY"?

IT'S PART OF WHAT THEY DO TO US.

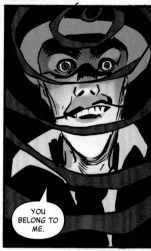

YOU BELONG TO ME.

KING DINGDONG RANGADING DING DING

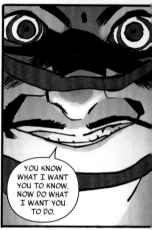

YOU KNOW WHAT I WANT YOU TO KNOW. NOW DO WHAT I WANT YOU TO DO.

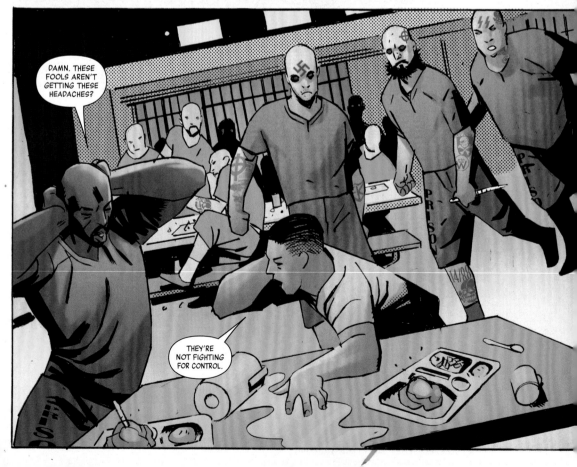

DAMN. THESE FOOLS AREN'T GETTING THESE HEADACHES?

THEY'RE NOT FIGHTING FOR CONTROL.

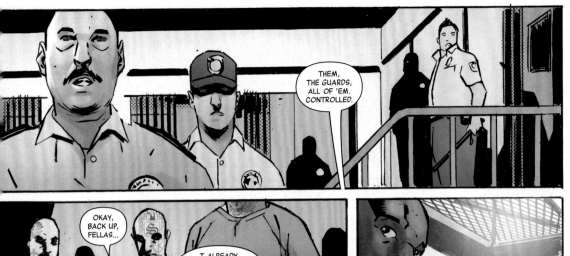

THEM, THE GUARDS, ALL OF 'EM. CONTROLLED.

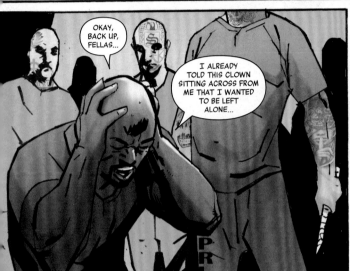

OKAY, BACK UP, FELLAS...

I ALREADY TOLD THIS CLOWN SITTING ACROSS FROM ME THAT I WANTED TO BE LEFT ALONE...

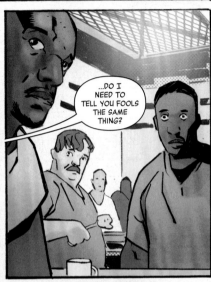

...DO I NEED TO TELL YOU FOOLS THE SAME THING?

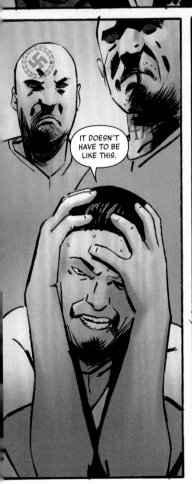

IT DOESN'T HAVE TO BE LIKE THIS.

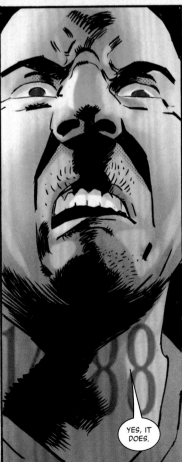

YES, IT DOES.

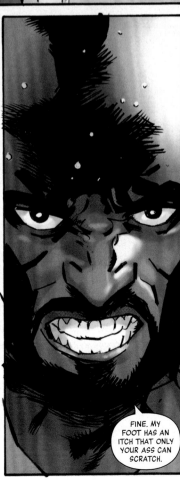

FINE. MY FOOT HAS AN ITCH THAT ONLY YOUR ASS CAN SCRATCH.

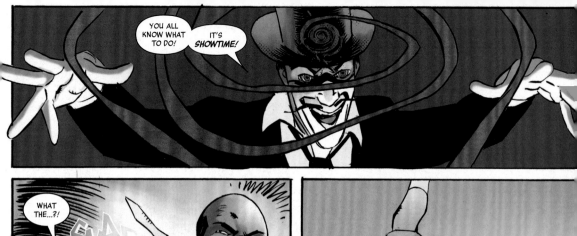

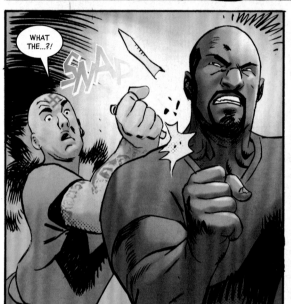

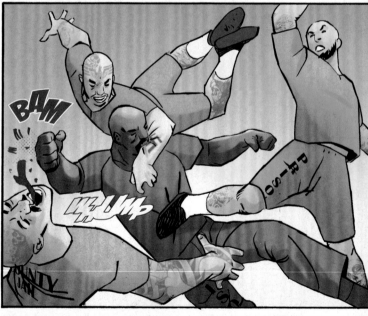

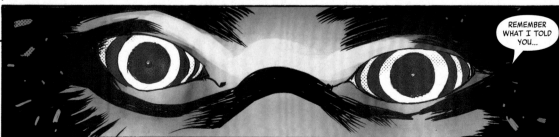

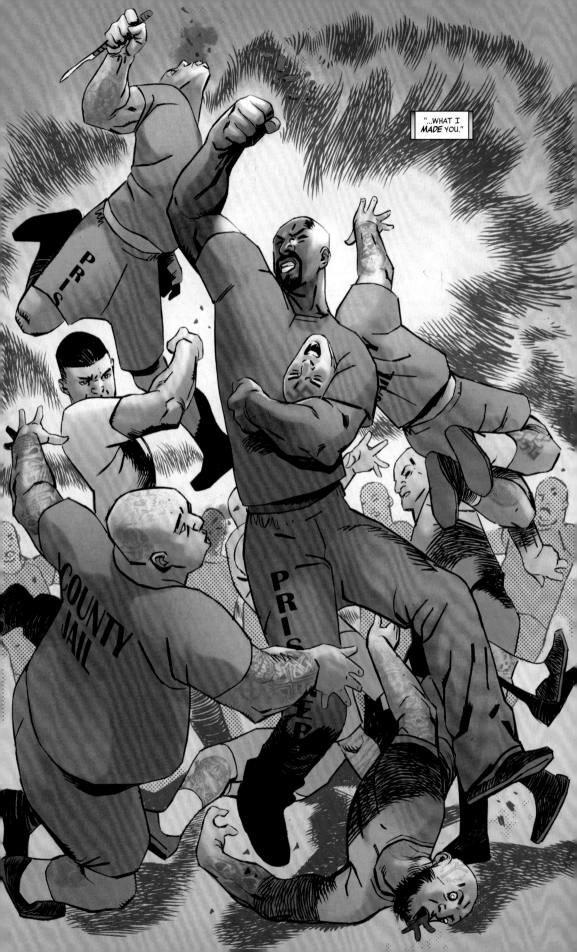

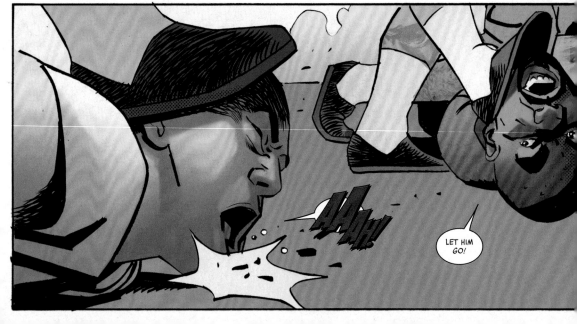

ARRR! MY...HEAD...

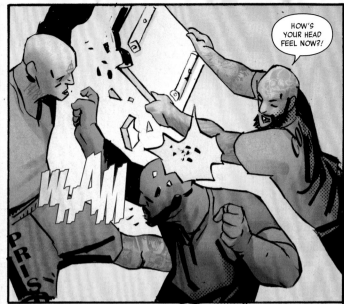

HOW'S YOUR HEAD FEEL NOW?!

WHAM

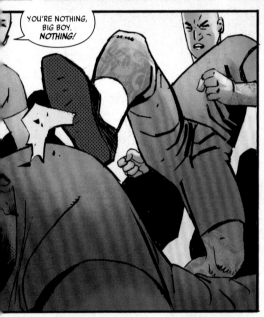

YOU'RE NOTHING, BIG BOY. NOTHING!

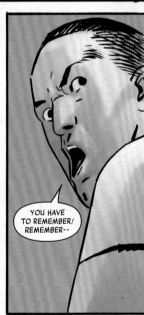

YOU HAVE TO REMEMBER! REMEMBER--

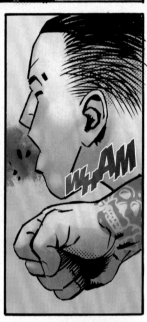

WHAM

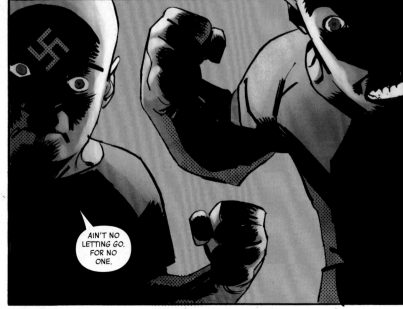

AIN'T NO LETTING GO. FOR NO ONE.

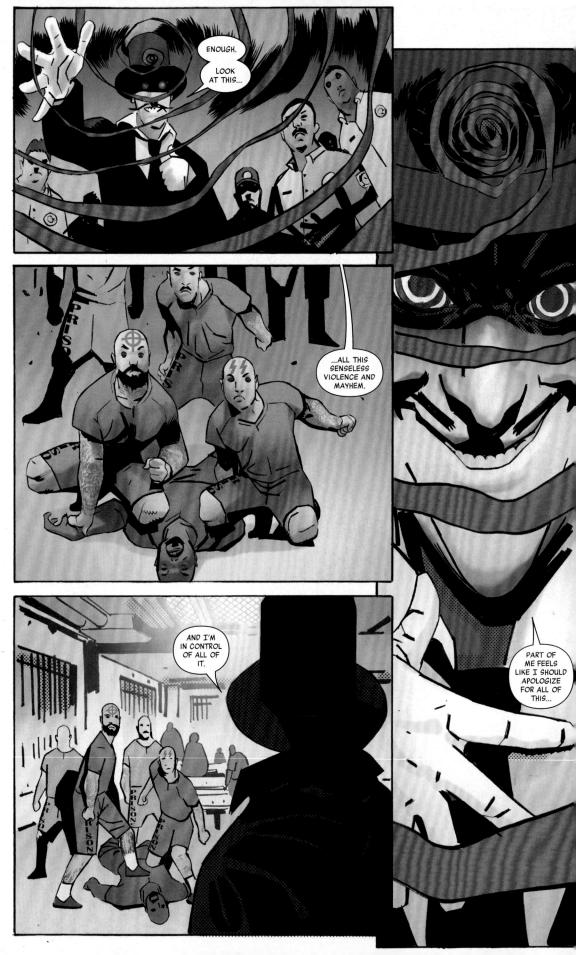

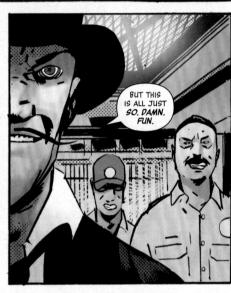
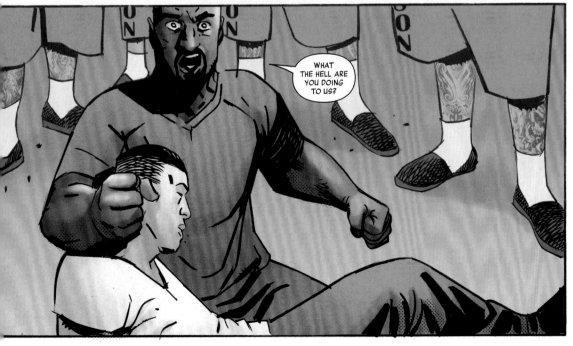

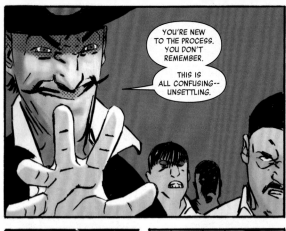

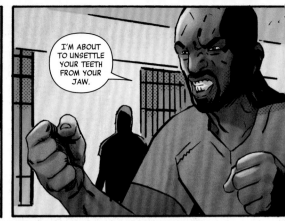

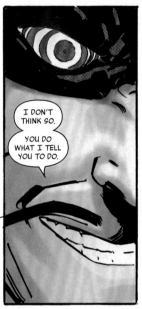

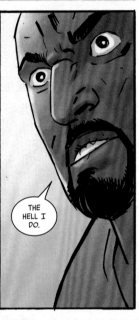

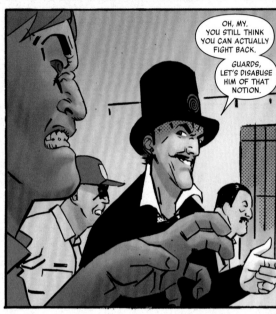

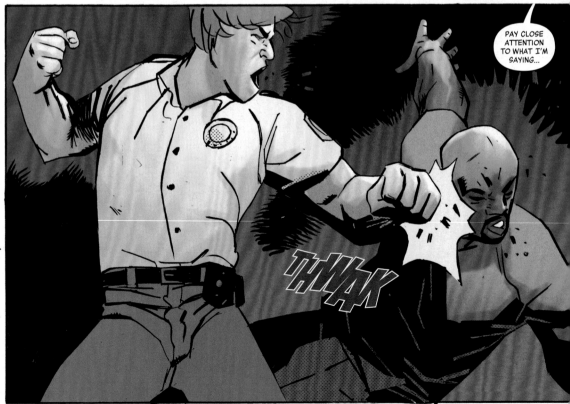

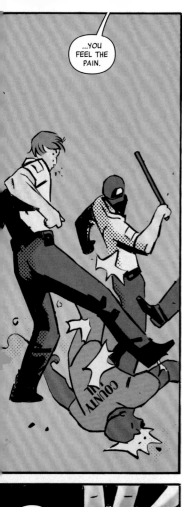

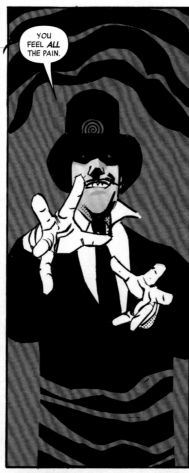

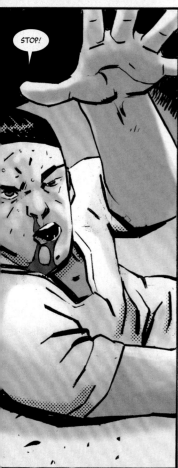

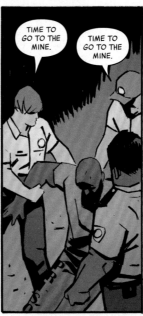
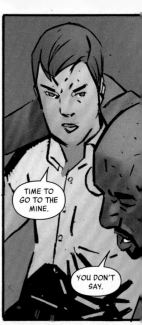
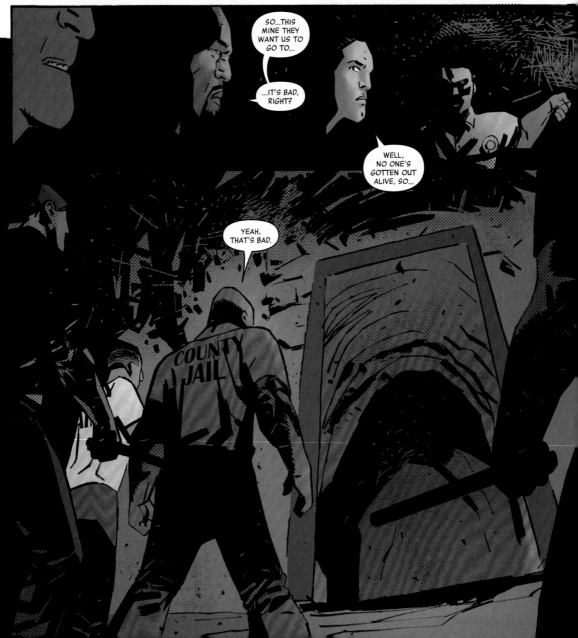

LEGACY

LUKE CAGE

166

#166 TRADING CARD VARIANT BY
JOHN TYLER CHRISTOPHER

168

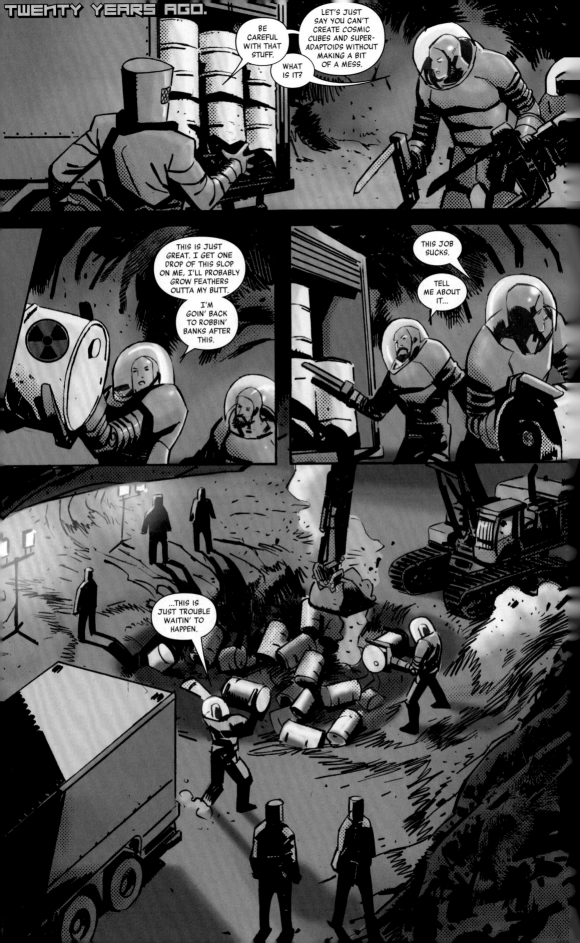

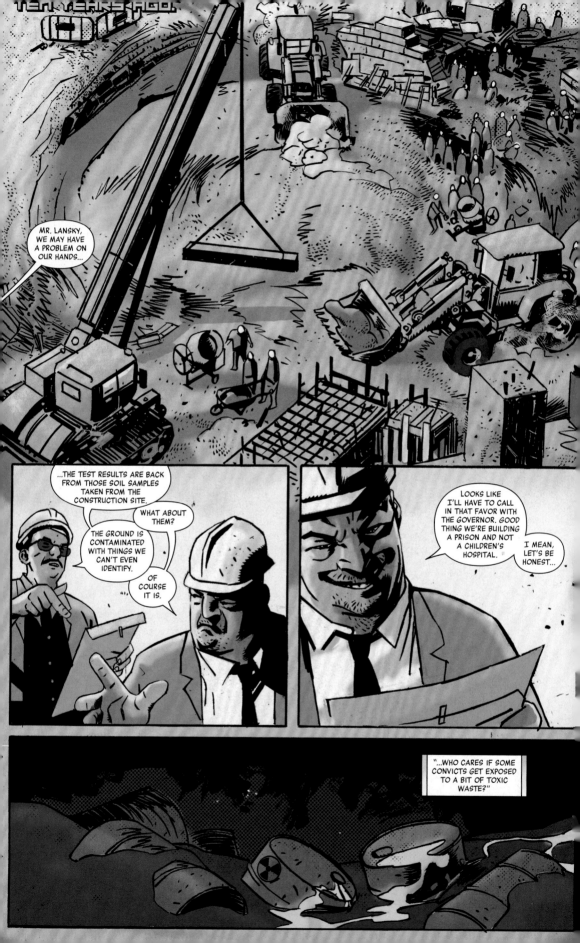

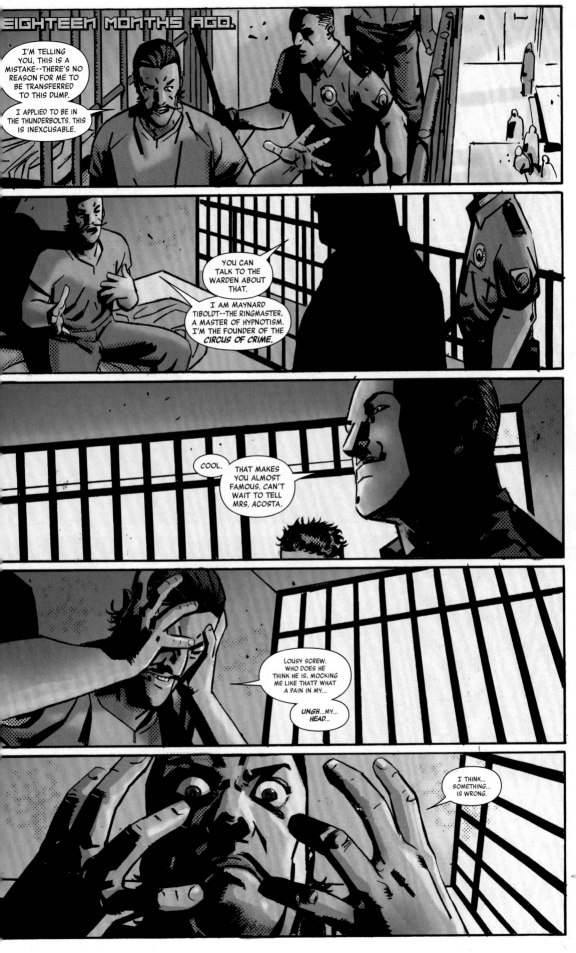

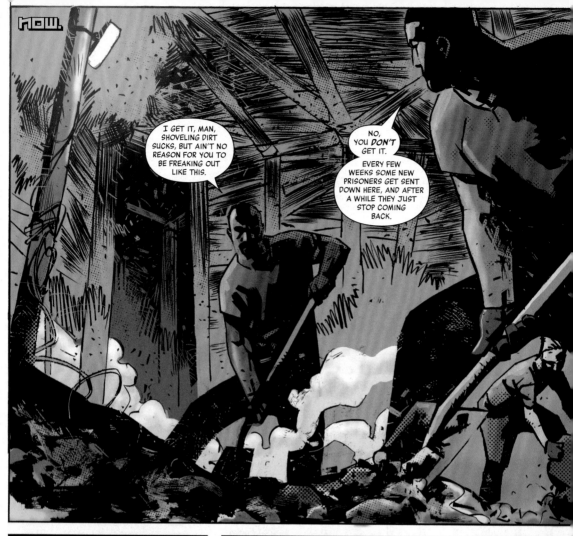

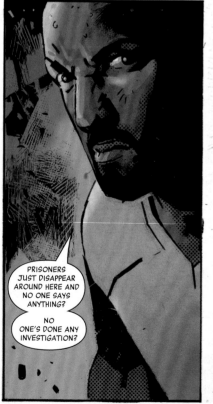

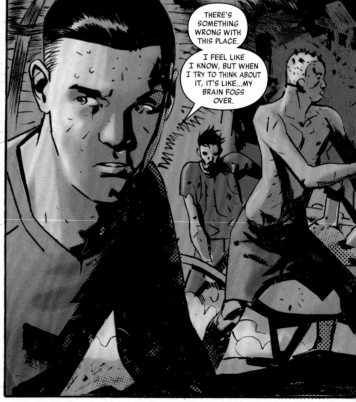

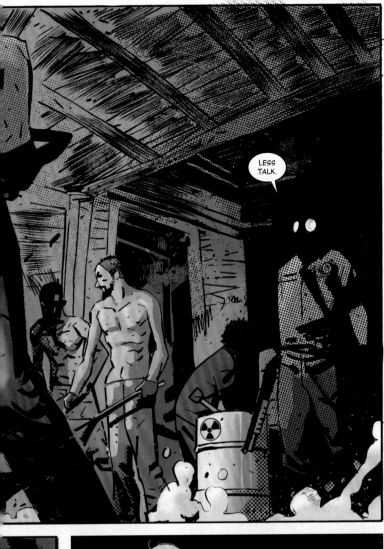
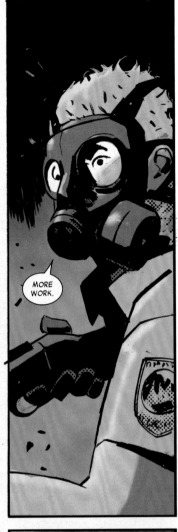

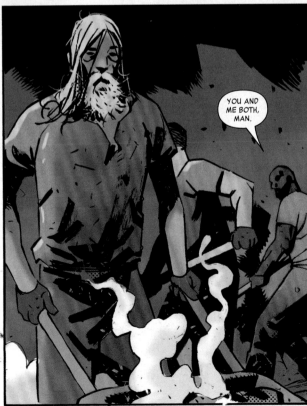

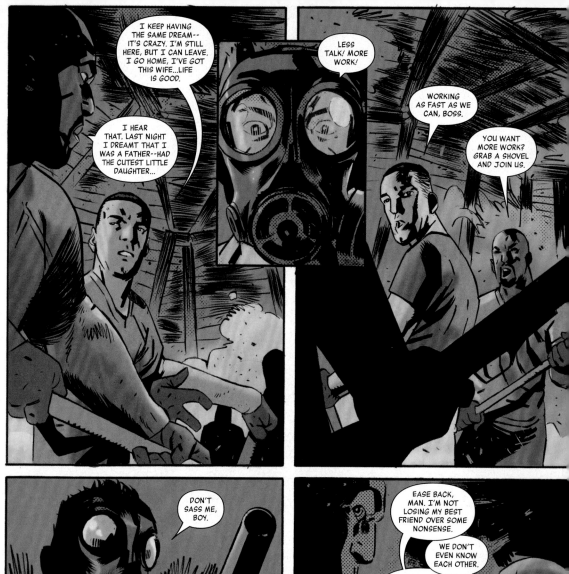

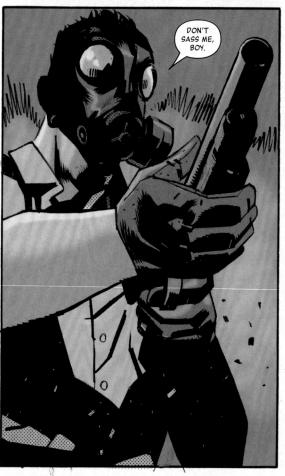

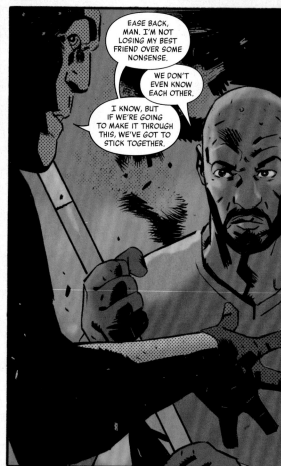

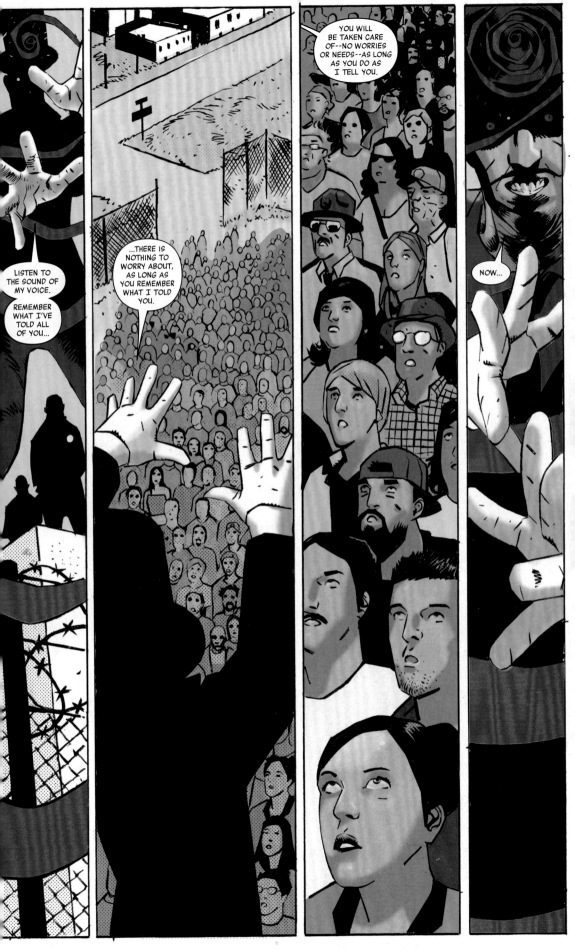

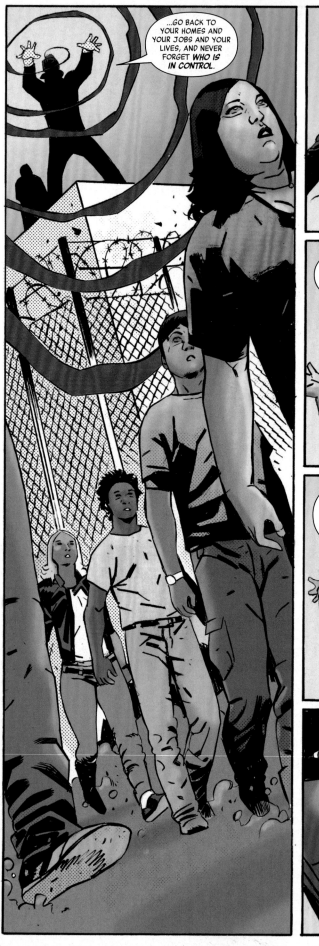

...GO BACK TO YOUR HOMES AND YOUR JOBS AND YOUR LIVES, AND NEVER FORGET *WHO IS IN CONTROL.*

UNGH...

I FEEL LIKE CRAP.

I DON'T KNOW HOW GUYS LIKE MAGNETO AND DR. DOOM DO IT-- TRYING TO TAKE OVER THE WORLD.

MAINTAINING CONTROL OF A PRISON AND ONE JERKWATER TOWN IS KICKING MY ASS.

BUT HEY, IT'S JUST LIKE JANET JACKSON SAID...

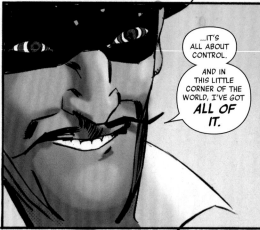

...IT'S ALL ABOUT CONTROL.

AND IN THIS LITTLE CORNER OF THE WORLD, I'VE GOT *ALL OF IT.*

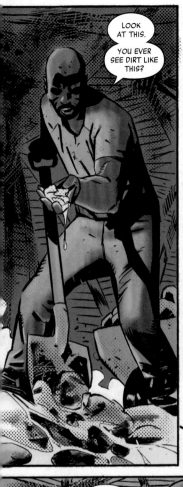

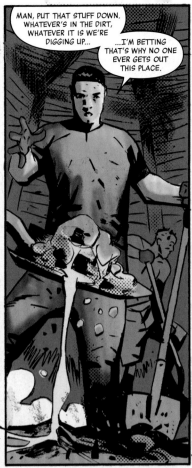

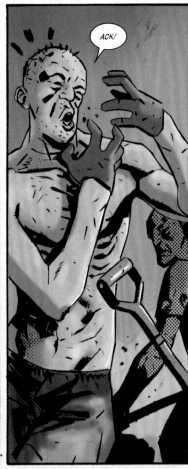

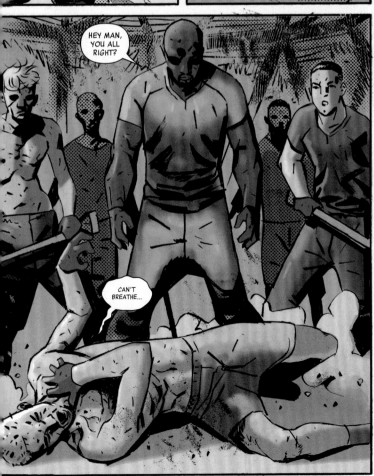

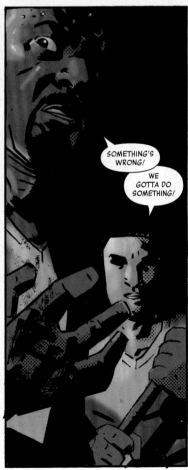

HERE YOU GO, BOSS.

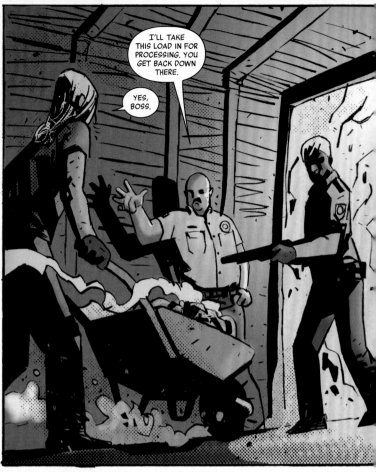

I'LL TAKE THIS LOAD IN FOR PROCESSING. YOU GET BACK DOWN THERE.

YES, BOSS.

I HATE BEIN' THIS CLOSE TO THIS STUFF--ESPECIALLY WITHOUT ANY PROTECTION.

ORDERS IS ORDERS.

AT LEAST WE AIN'T EXPOSED TO IT LIKE THOSE SCHMUCKS DIGGING IT UP.

THAT BRINGS ME SO MUCH COMFORT.

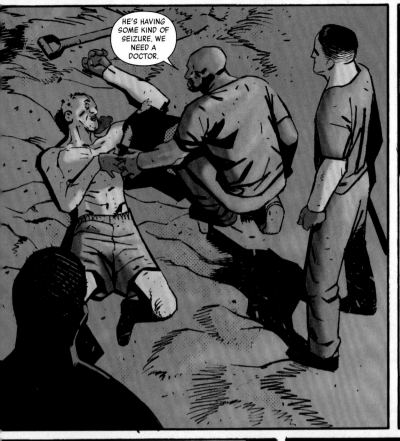

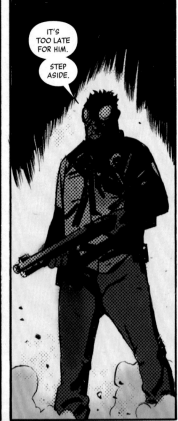

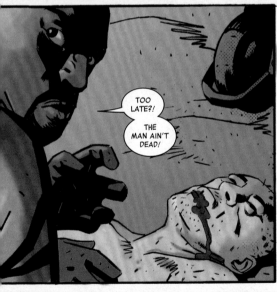

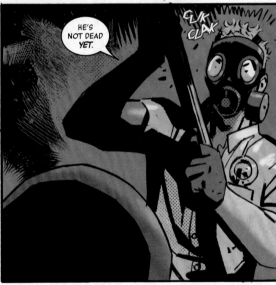

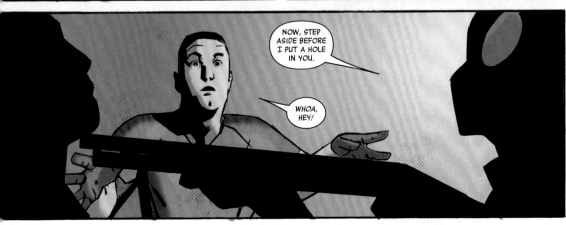

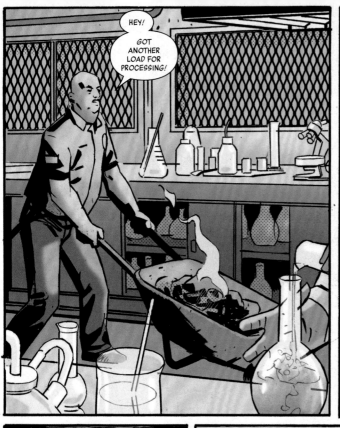
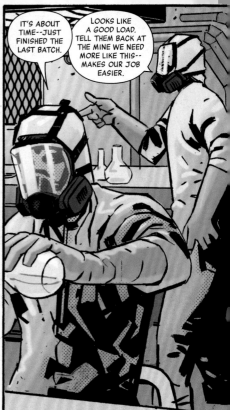
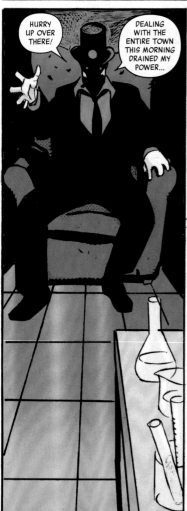

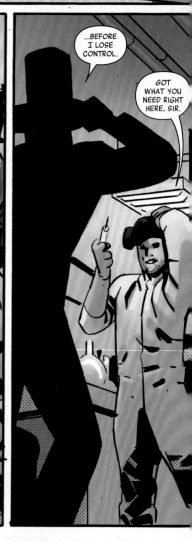

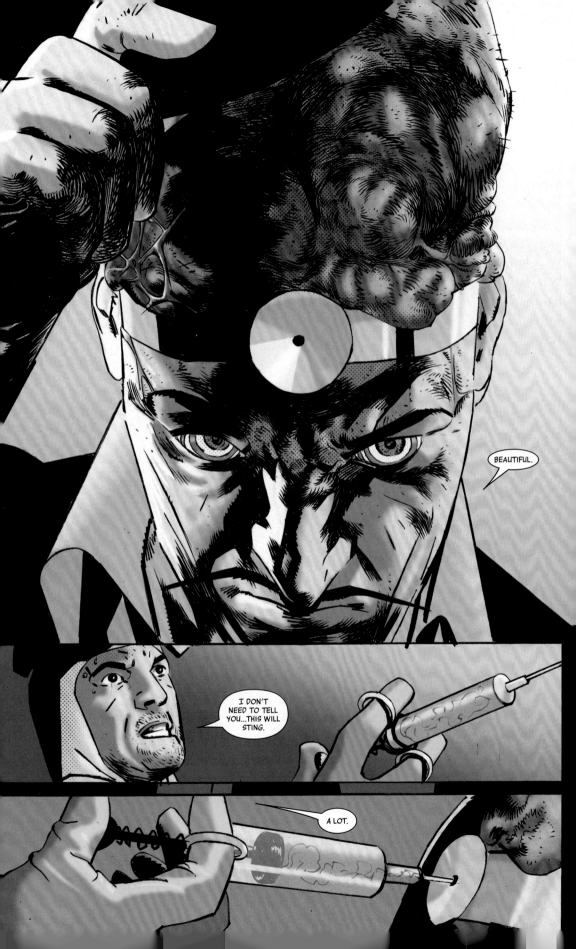

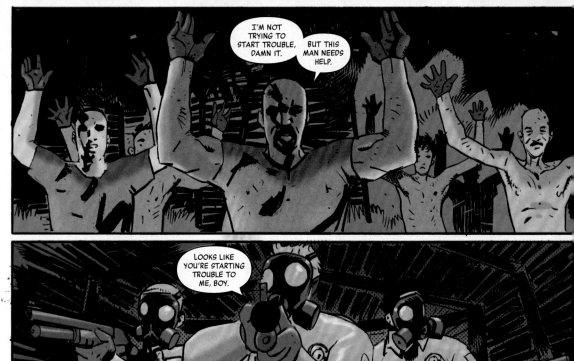

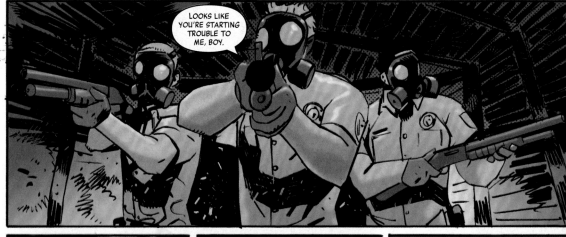

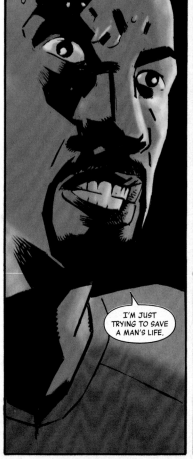

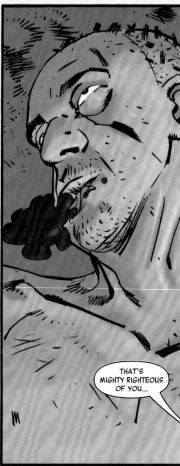

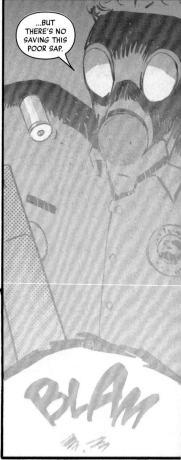

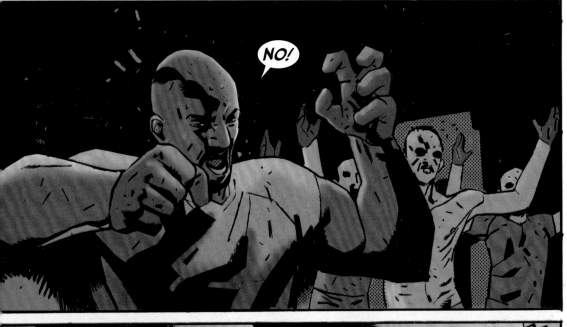

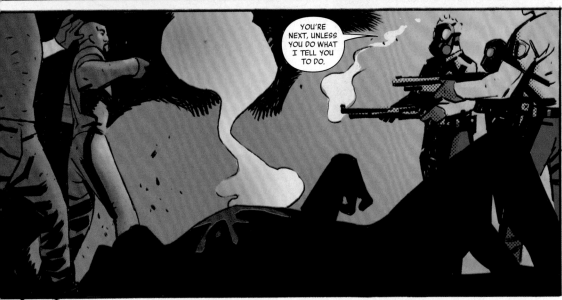

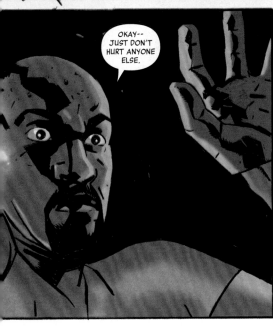

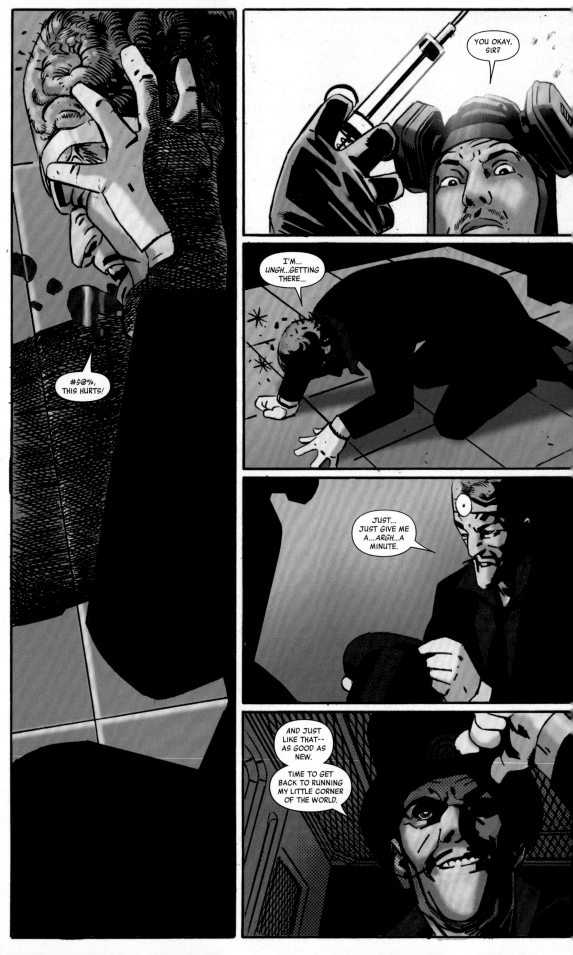

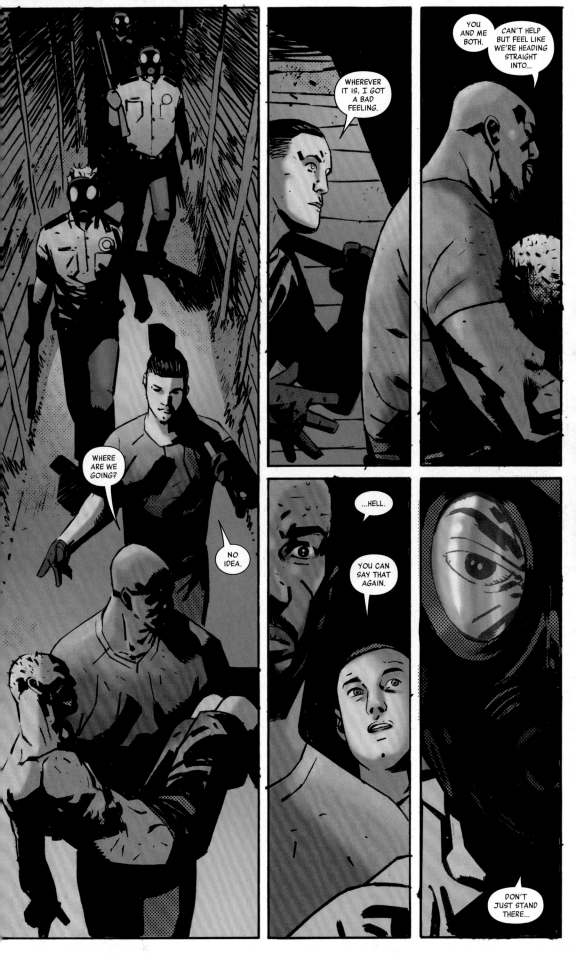

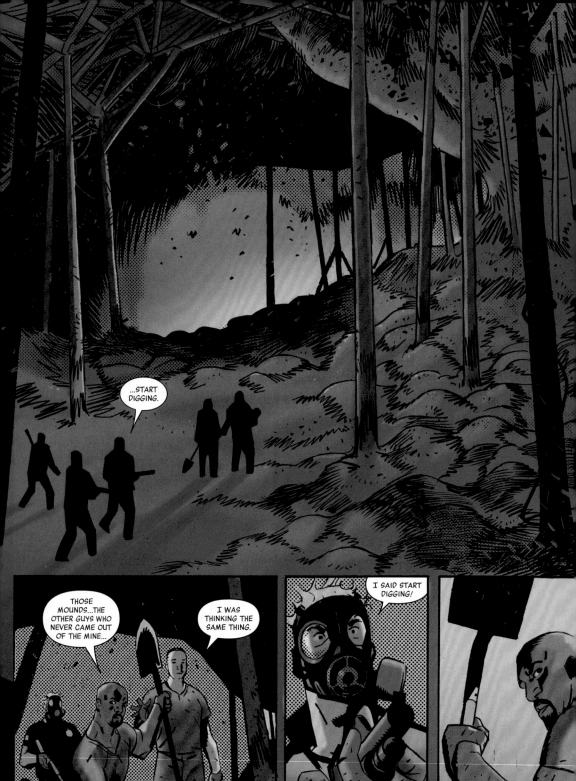
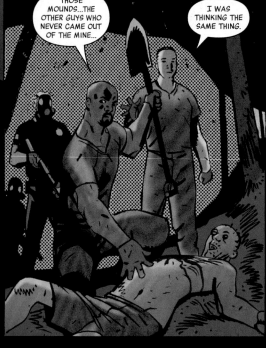

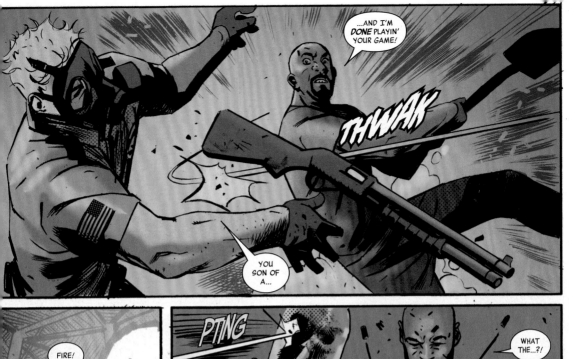

...AND I'M **DONE** PLAYIN' YOUR GAME!

THWAK

YOU SON OF A...

FIRE!

PTING

PTING

PTING

WHAT THE...?!

KRAAAK

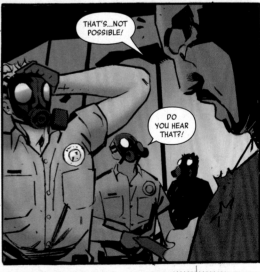

THAT'S...NOT POSSIBLE!

DO YOU HEAR THAT?!

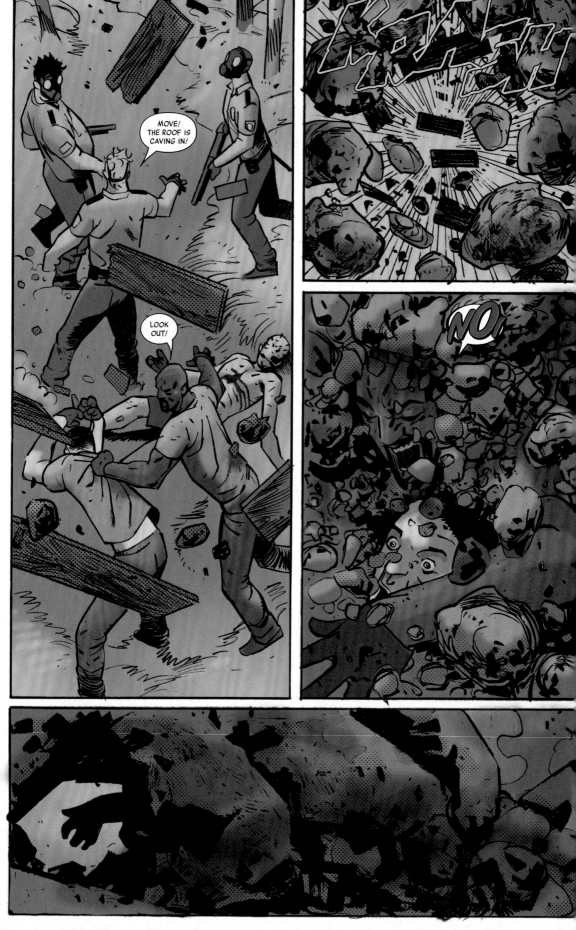

#166 LEGACY HEADSHOT VARIANT BY

MIKE McKONE & **ANDY TROY**

169

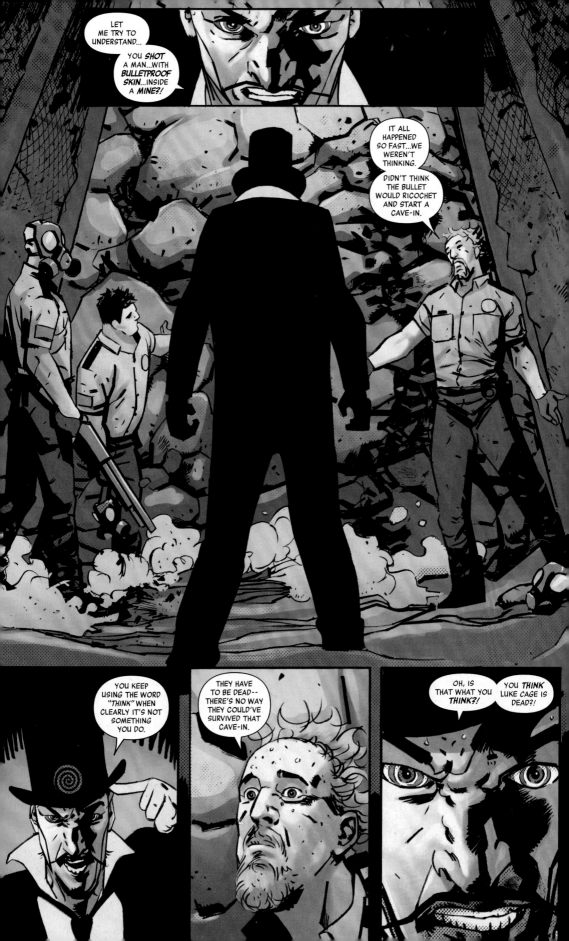

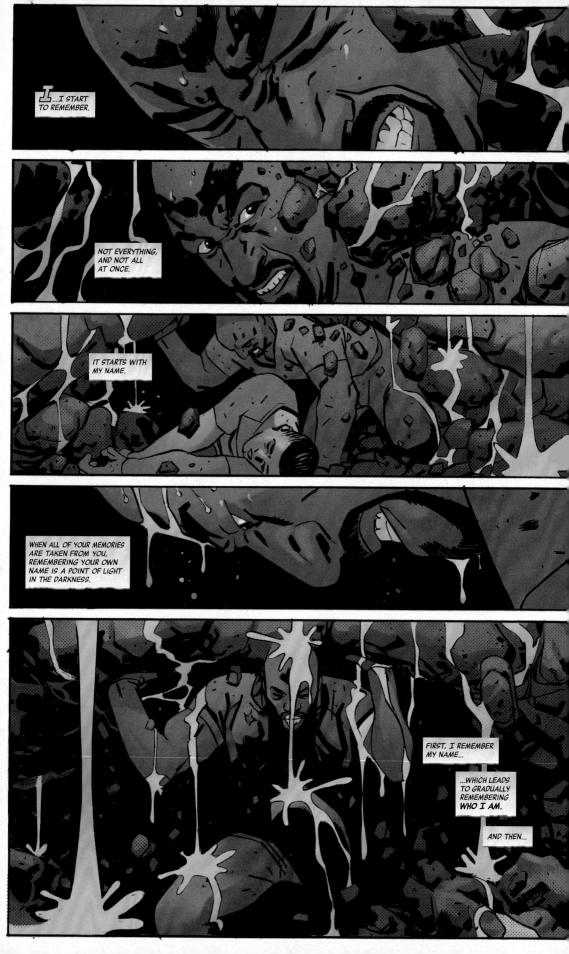

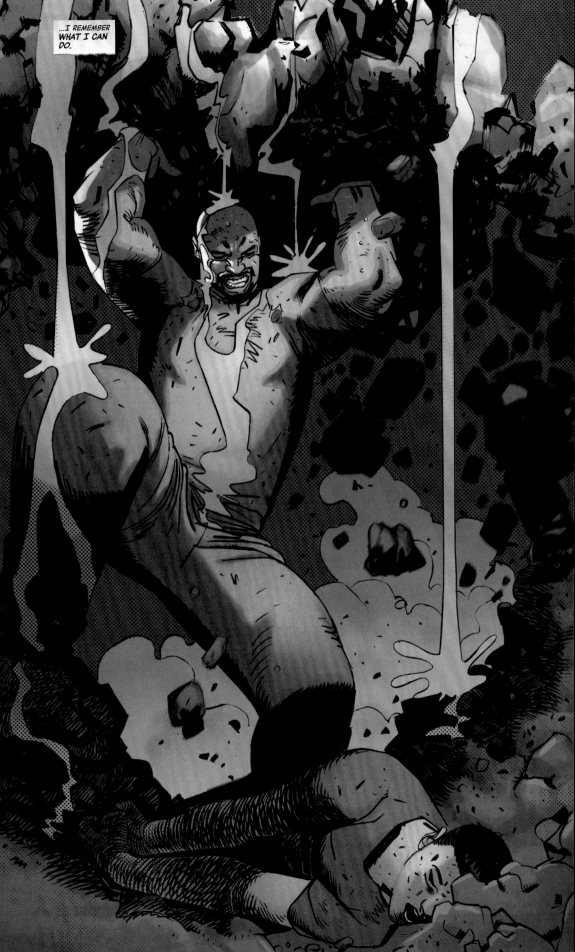

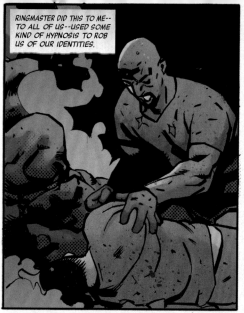

RINGMASTER DID THIS TO ME-- TO ALL OF US--USED SOME KIND OF HYPNOSIS TO ROB US OF OUR IDENTITIES.

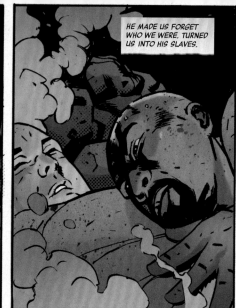

HE MADE US FORGET WHO WE WERE. TURNED US INTO HIS SLAVES.

HE RUINED LIVES. KILLED PEOPLE.

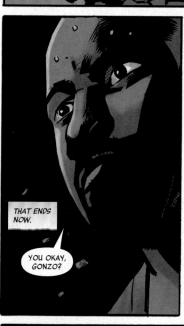

THAT ENDS NOW.

YOU OKAY, GONZO?

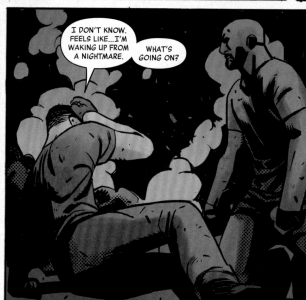

I DON'T KNOW. FEELS LIKE...I'M WAKING UP FROM A NIGHTMARE.

WHAT'S GOING ON?

RINGMASTER? YOU MEAN THAT IDIOT, MAYNARD TIBOLDT?

THAT'S HIM...

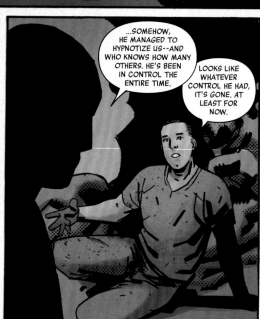

...SOMEHOW, HE MANAGED TO HYPNOTIZE US--AND WHO KNOWS HOW MANY OTHERS. HE'S BEEN IN CONTROL THE ENTIRE TIME.

LOOKS LIKE WHATEVER CONTROL HE HAD, IT'S GONE. AT LEAST FOR NOW.

=COUGH=
=COUGH=

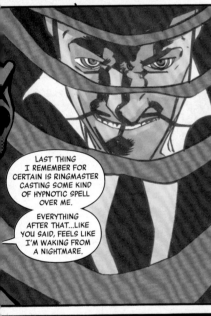

LAST THING I REMEMBER FOR CERTAIN IS RINGMASTER CASTING SOME KIND OF HYPNOTIC SPELL OVER ME.

EVERYTHING AFTER THAT...LIKE YOU SAID, FEELS LIKE I'M WAKING FROM A NIGHTMARE.

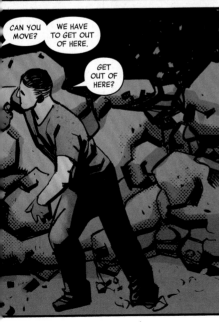

CAN YOU MOVE?

WE HAVE TO GET OUT OF HERE.

GET OUT OF HERE?

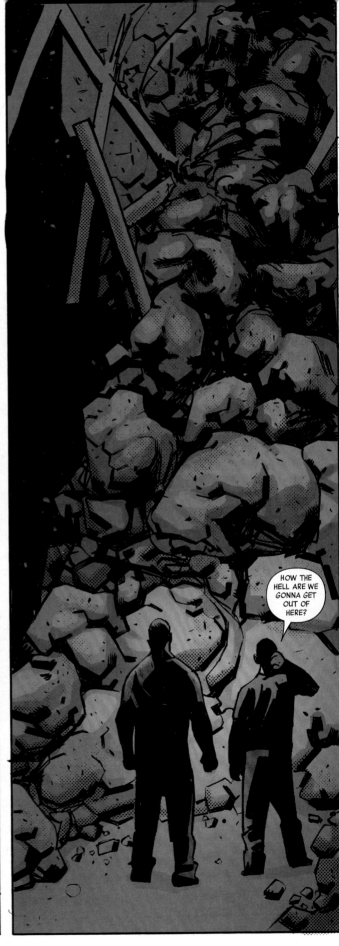

HOW THE HELL ARE WE GONNA GET OUT OF HERE?

WE CAN FIND SOME OTHER PLACE TO ENTER THE MINE--THAT'S NOT WHAT HAS ME CONCERNED.

MY CONCERN IS LUKE CAGE--IF HE SURVIVED THAT CAVE-IN, IF HE GETS OUT OF THERE...

...*THAT* COULD BE TROUBLE. DO YOU KNOW HOW DIFFICULT IT IS TO MAINTAIN CONTROL OF ALL OF YOU?

IT'S NOT EASY, I'LL TELL YOU THAT.

WHAT DO YOU WANT US TO DO, SIR?

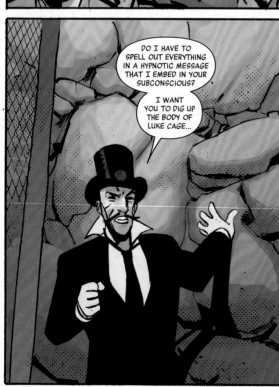

DO I HAVE TO SPELL OUT EVERYTHING IN A HYPNOTIC MESSAGE THAT I EMBED IN YOUR SUBCONSCIOUS?

I WANT YOU TO DIG UP THE BODY OF LUKE CAGE...

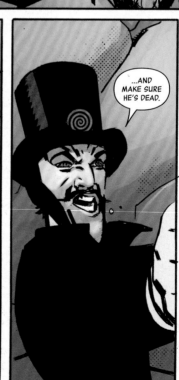

...AND MAKE SURE HE'S DEAD.

THWAK

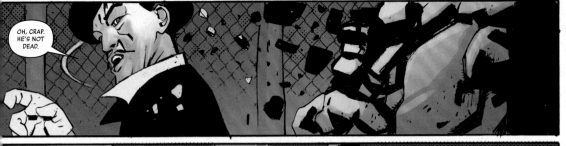

OH, CRAP. HE'S NOT DEAD.

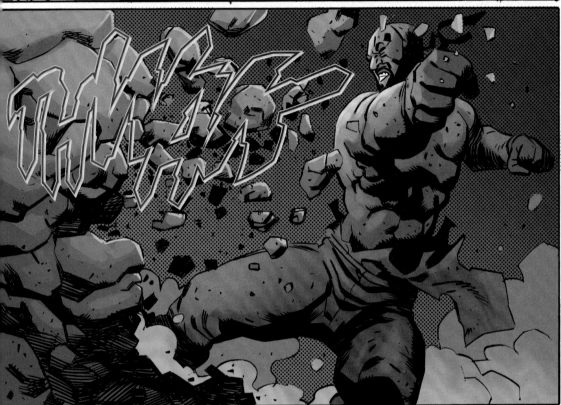

THWIP THWIP

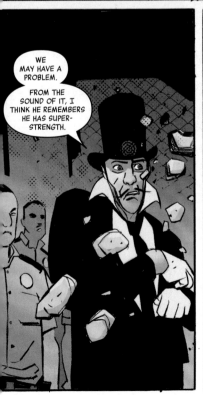

WE MAY HAVE A PROBLEM.

FROM THE SOUND OF IT, I THINK HE REMEMBERS HE HAS SUPER-STRENGTH.

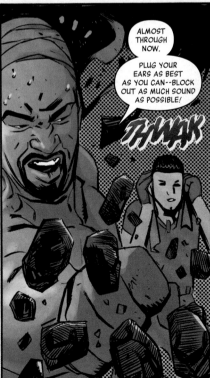

ALMOST THROUGH NOW.

PLUG YOUR EARS AS BEST AS YOU CAN--BLOCK OUT AS MUCH SOUND AS POSSIBLE!

THWAK

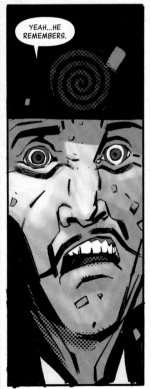

YEAH...HE REMEMBERS.

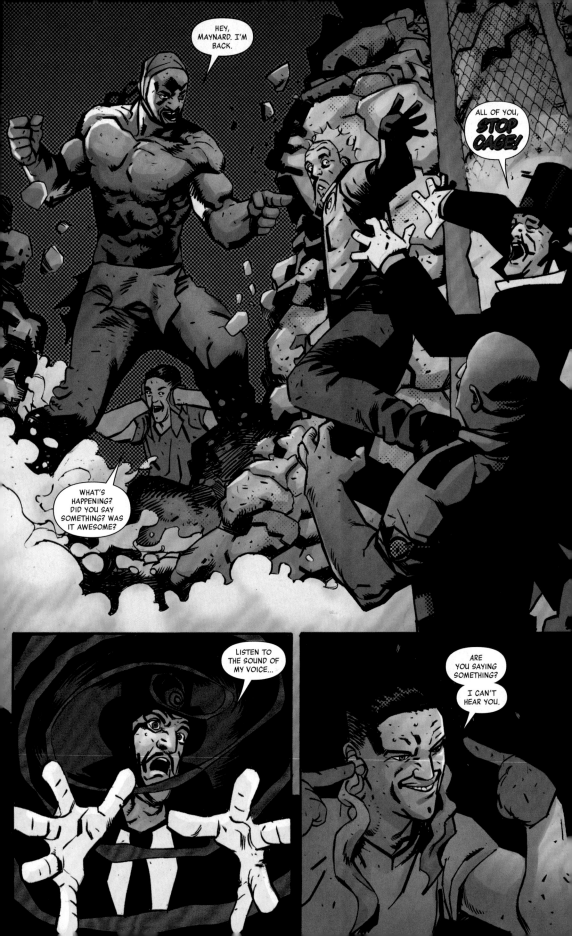

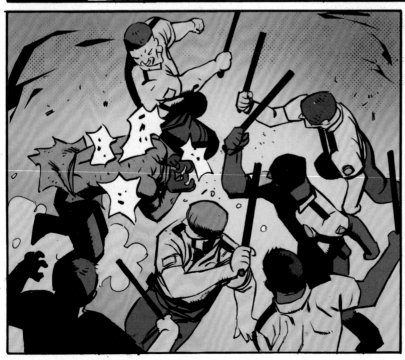

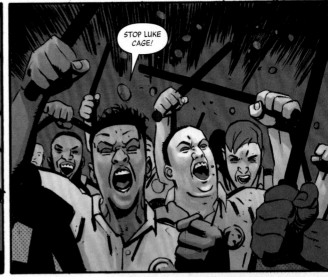

STOP LUKE CAGE!

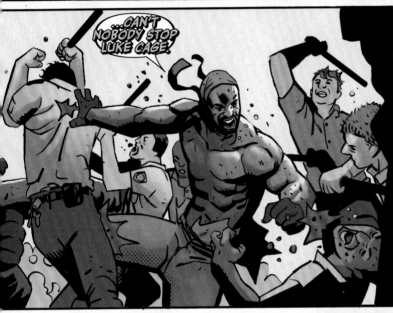

...CAN'T NOBODY STOP LUKE CAGE!

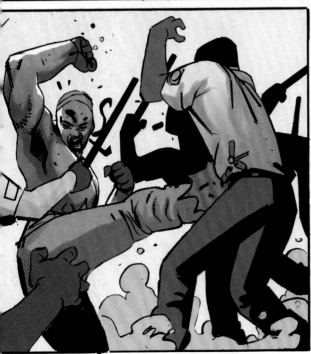

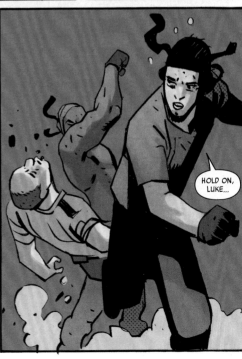

HOLD ON, LUKE...

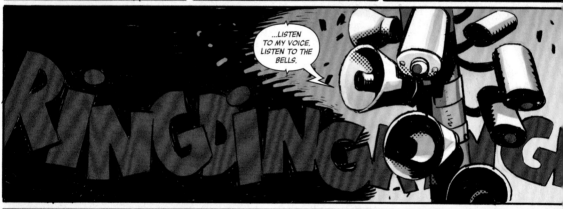

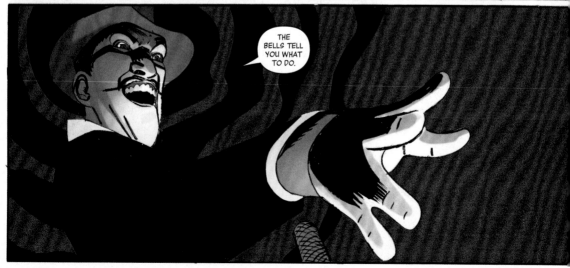

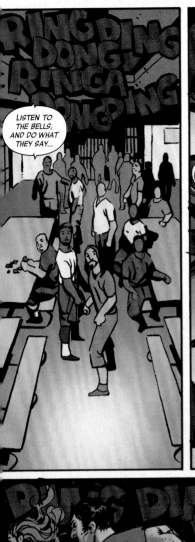
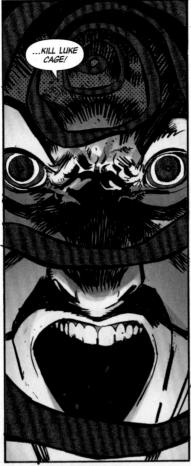
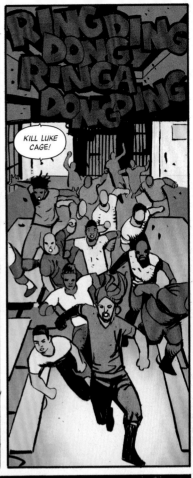
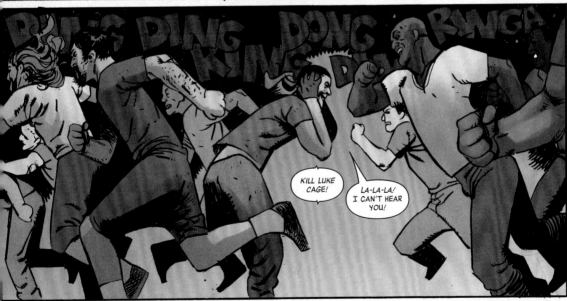

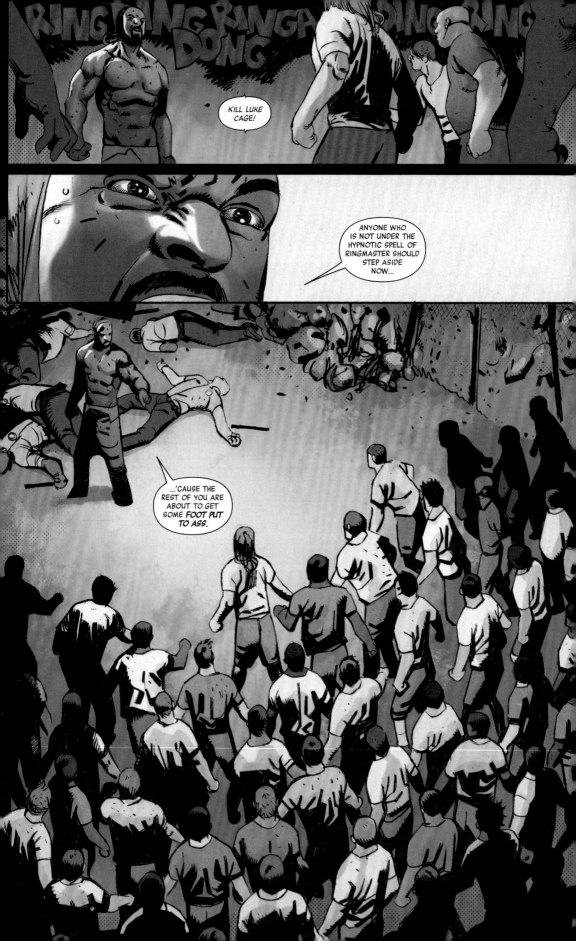

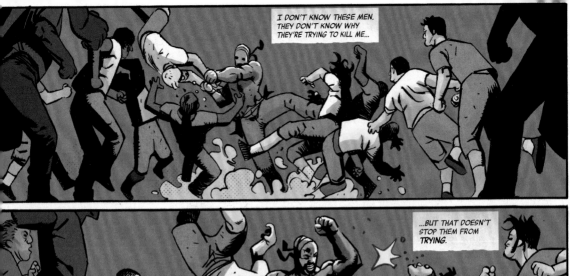

I DON'T KNOW THESE MEN. THEY DON'T KNOW WHY THEY'RE TRYING TO KILL ME...

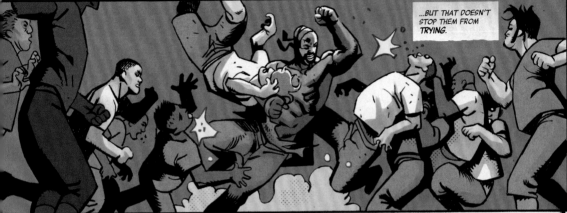

...BUT THAT DOESN'T STOP THEM FROM **TRYING**.

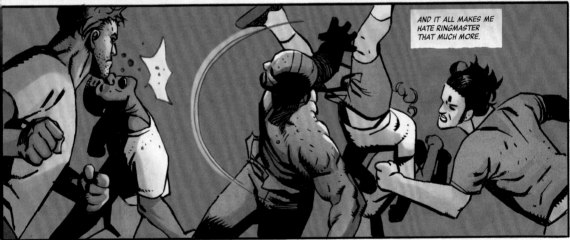

AND IT ALL MAKES ME HATE RINGMASTER THAT MUCH MORE.

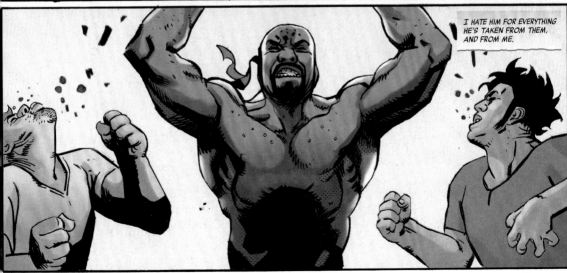

I HATE HIM FOR EVERYTHING HE'S TAKEN FROM THEM, AND FROM ME.

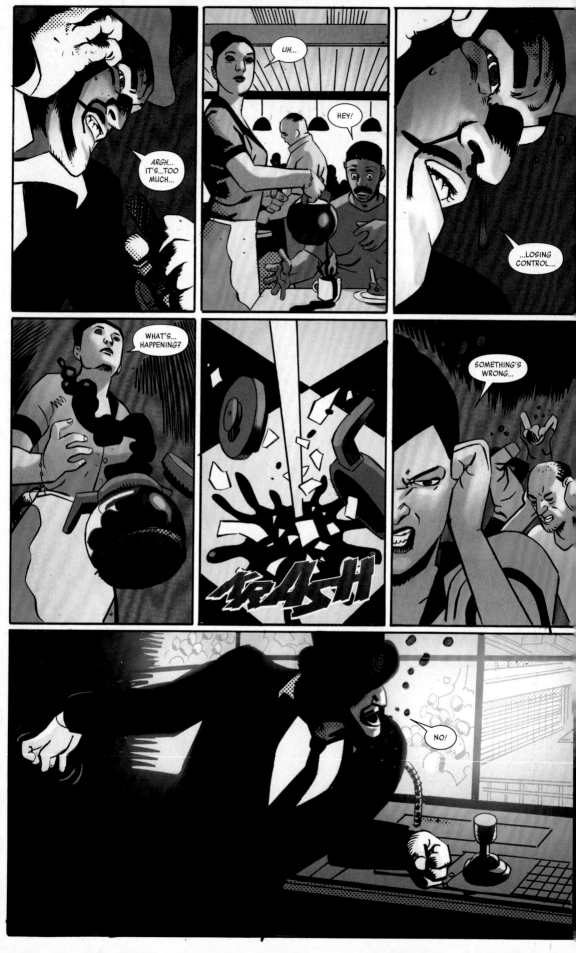

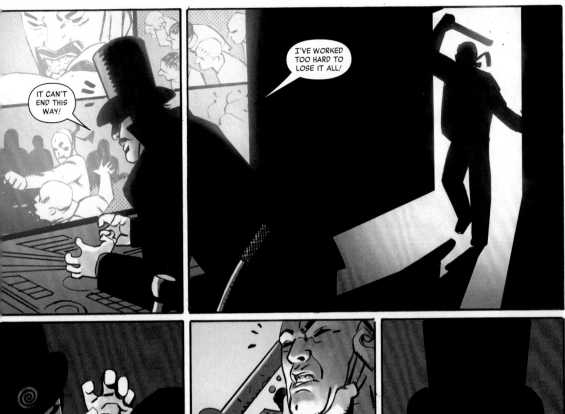

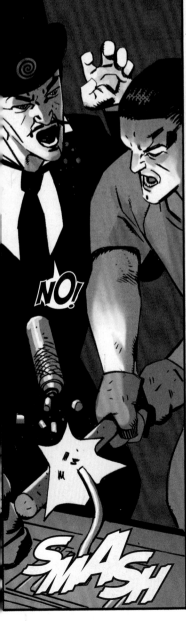

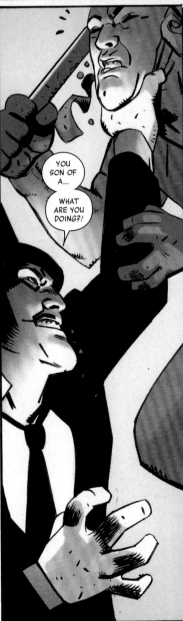

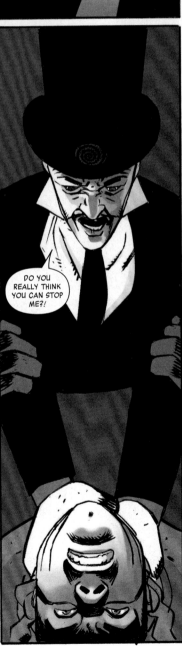

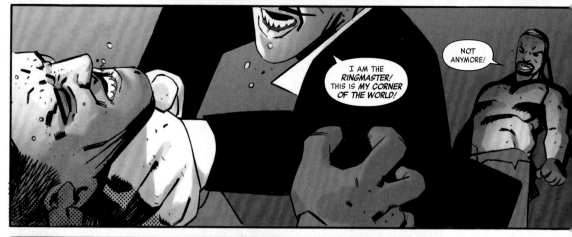

I AM THE *RINGMASTER!* THIS IS *MY CORNER* OF THE WORLD!

NOT ANYMORE!

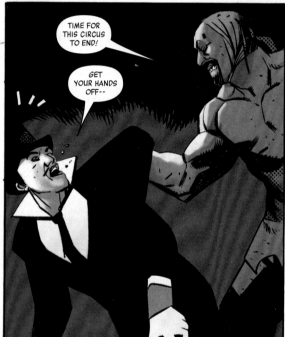

TIME FOR THIS CIRCUS TO END!

GET YOUR HANDS OFF--

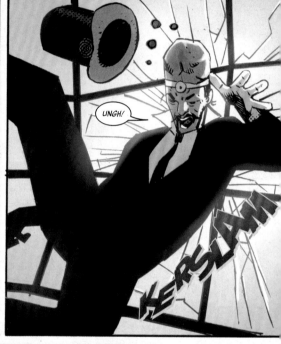

UNGH!

KERSLAM

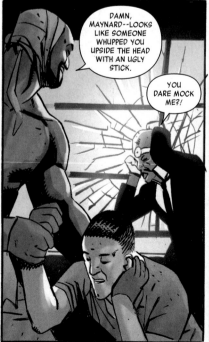

DAMN, MAYNARD--LOOKS LIKE SOMEONE WHUPPED YOU UPSIDE THE HEAD WITH AN UGLY STICK.

YOU DARE MOCK ME?!

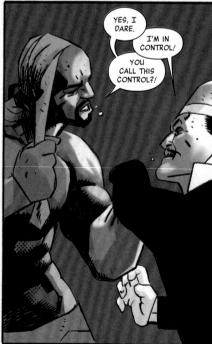

YES, I DARE.

I'M IN CONTROL!

YOU CALL THIS CONTROL?!

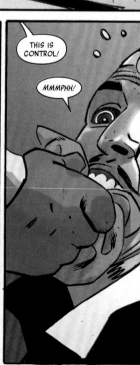

THIS IS CONTROL!

MMMPHH!

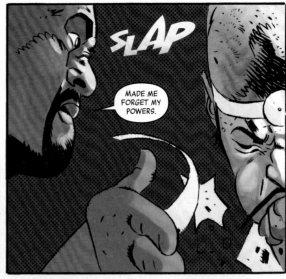
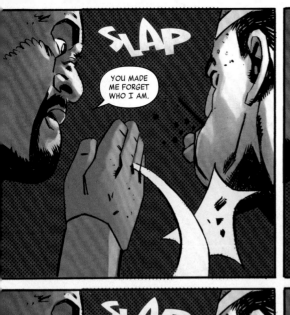

SLAP

YOU MADE ME FORGET WHO I AM.

SLAP

MADE ME FORGET MY POWERS.

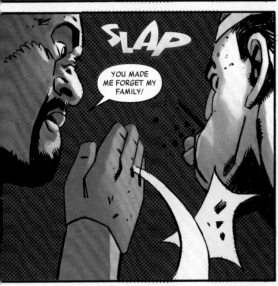
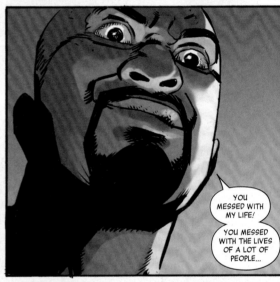

SLAP

YOU MADE ME FORGET MY FAMILY!

YOU MESSED WITH MY LIFE!

YOU MESSED WITH THE LIVES OF A LOT OF PEOPLE...

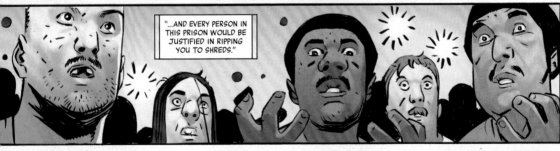

"...AND EVERY PERSON IN THIS PRISON WOULD BE JUSTIFIED IN RIPPING YOU TO SHREDS."

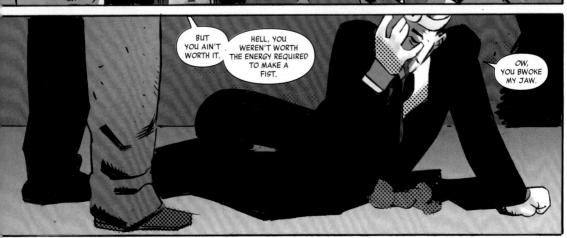

BUT YOU AIN'T WORTH IT.

HELL, YOU WEREN'T WORTH THE ENERGY REQUIRED TO MAKE A FIST.

OW, YOU BWOKE MY JAW.

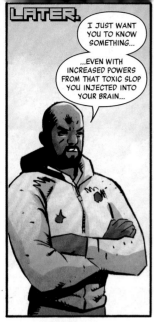

LATER.

I JUST WANT YOU TO KNOW SOMETHING...

...EVEN WITH INCREASED POWERS FROM THAT TOXIC SLOP YOU INJECTED INTO YOUR BRAIN...

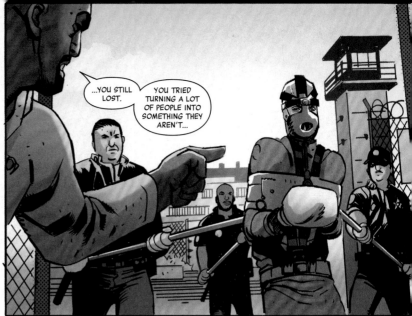

...YOU STILL LOST.

YOU TRIED TURNING A LOT OF PEOPLE INTO SOMETHING THEY AREN'T...

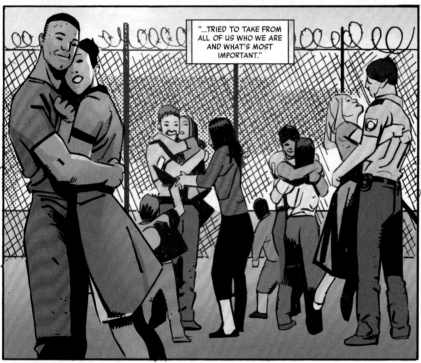

"...TRIED TO TAKE FROM ALL OF US WHO WE ARE AND WHAT'S MOST IMPORTANT."

WHICH IS WHY HANDING YOU YOUR ASS IS AN ESPECIALLY SWEET VICTORY.

NOW...

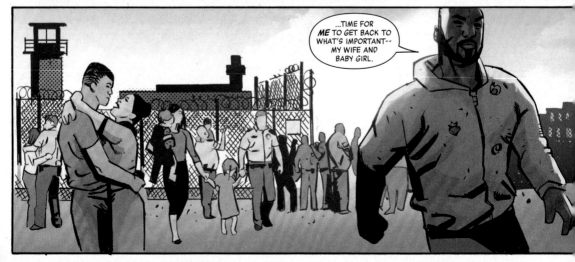

...TIME FOR *ME* TO GET BACK TO WHAT'S IMPORTANT-- MY WIFE AND BABY GIRL.

POWER MAIL

Let me tell you about this kid. Her name is Astrid, she's four years old and she's one of the most amazing human beings I've ever met. She is smart, funny, her favorite snake is the black mamba and she loves super heroes. Ask her about any super hero, and she can tell you who they are and their origin story, but it doesn't stop there, because Astrid loves to make up her own stories. She often starts by saying, "Tell me a story," but it only takes about a minute before she takes over the narrative, bending it and shaping it into something of pure brilliance. She is what most comic-book writers start out being, and what we work so hard to continue being.

This issue of *Luke Cage* – the final issue – has been in development since I started writing *Power Man and Iron Fist*. From the very beginning, I wanted to write an entire issue dedicated to Luke being a father spending time with his daughter Danielle. In the entire history of Luke Cage (which spans more than 40 years), there is nothing more interesting or compelling than his becoming a father. Unfortunately, for various reasons, I never got to build on the relationship between Luke and Danielle the way I wanted to, and for me, my combined run on *Power Man and Iron Fist* and *Luke Cage* will always be less than it could have been because I never really got to explore what truly makes Luke one of the best characters in the Marvel Universe – his love and dedication to his daughter.

When word came that *Luke Cage* was ending, I knew I had to do a story revolving around Luke and Danielle. Inspired by a classic issue of *Uncanny X-Men* and the movie *The Princess Bride*, I decided to craft a simple tale of a father telling his daughter a bedtime story. It seemed easy at the time, but proved to be far more challenging than I had anticipated. The problem was that Danielle wasn't a character in the story so much as she was a prop – Luke was telling her the story, and she was sitting back and listening. It wasn't working at all. And that's where Astrid comes in.

If there is any sense of reality or authenticity to this issue, it is because it was inspired by the fine art of telling Astrid a story, her taking over the narrative, turning it into her own thing and making it so much better than when it started. What could have easily been a sad or cynical issue for me to write turned into the most fun I've had in many years, and it is all because of a four-year-old girl whose imagination burns so bright that it brings light to everyone around her.

I want to thank everyone who has supported *Luke Cage*, and give special shout-outs to my editorial team, as well as the artists who made each issue come alive. I dedicate this final issue of *Luke Cage* to my dear friend Astrid. Not only does she inspire me, she reminds me of why I love super heroes and comic books. Astrid, this one is for you. Love you, kid.

DAVID F. WALKER

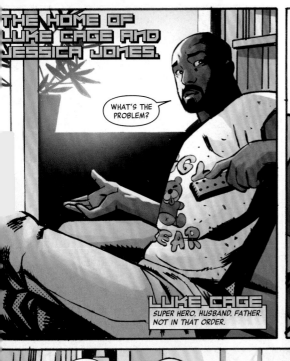

THE HOME OF LUKE CAGE AND JESSICA JONES.

WHAT'S THE PROBLEM?

LUKE CAGE
SUPER HERO. HUSBAND. FATHER. NOT IN THAT ORDER.

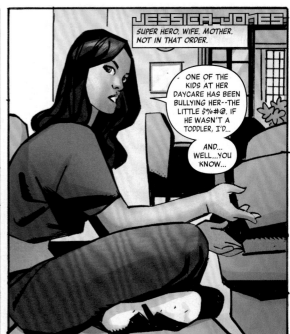

JESSICA JONES:
SUPER HERO. WIFE. MOTHER. NOT IN THAT ORDER.

ONE OF THE KIDS AT HER DAYCARE HAS BEEN BULLYING HER--THE LITTLE $%#@. IF HE WASN'T A TODDLER, I'D...

AND... WELL...YOU KNOW...

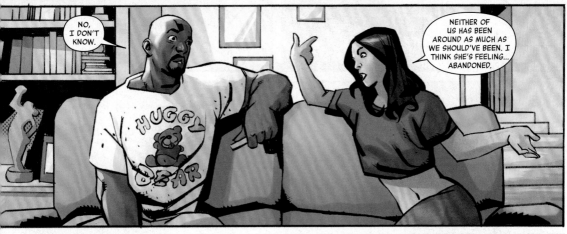

NO, I DON'T KNOW.

NEITHER OF US HAS BEEN AROUND AS MUCH AS WE SHOULD'VE BEEN. I THINK SHE'S FEELING... ABANDONED.

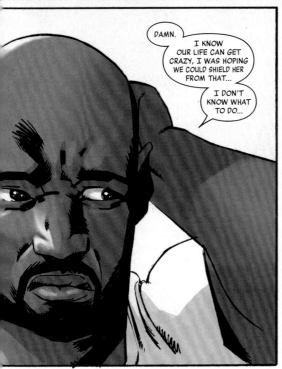

DAMN. I KNOW OUR LIFE CAN GET CRAZY, I WAS HOPING WE COULD SHIELD HER FROM THAT...

I DON'T KNOW WHAT TO DO...

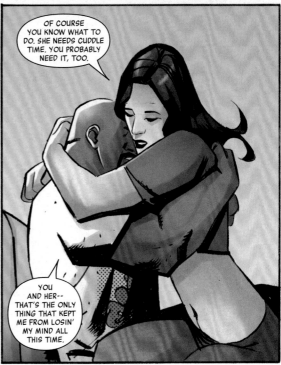

OF COURSE YOU KNOW WHAT TO DO. SHE NEEDS CUDDLE TIME. YOU PROBABLY NEED IT, TOO.

YOU AND HER-- THAT'S THE ONLY THING THAT KEPT ME FROM LOSIN' MY MIND ALL THIS TIME.

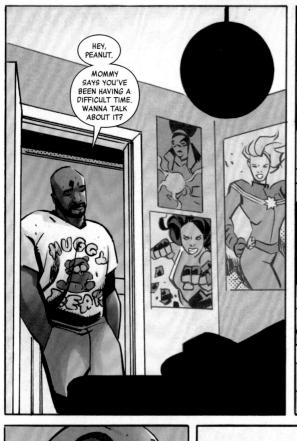

HEY, PEANUT.

MOMMY SAYS YOU'VE BEEN HAVING A DIFFICULT TIME. WANNA TALK ABOUT IT?

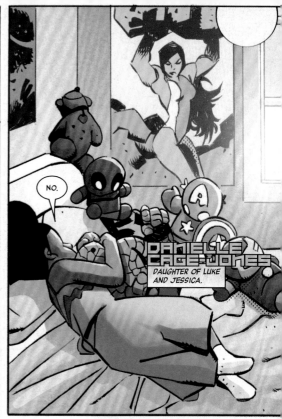

NO.

DANIELLE CAGE-JONES
Daughter of Luke and Jessica.

OKAY.

WHAT ABOUT...

...CUDDLE TIME?

CUDDLE TIME?

YEAH. I NEED SOME HUGS.

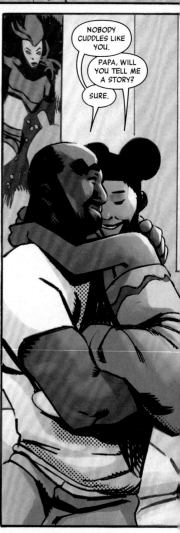

NOBODY CUDDLES LIKE YOU.

PAPA, WILL YOU TELL ME A STORY?

SURE.

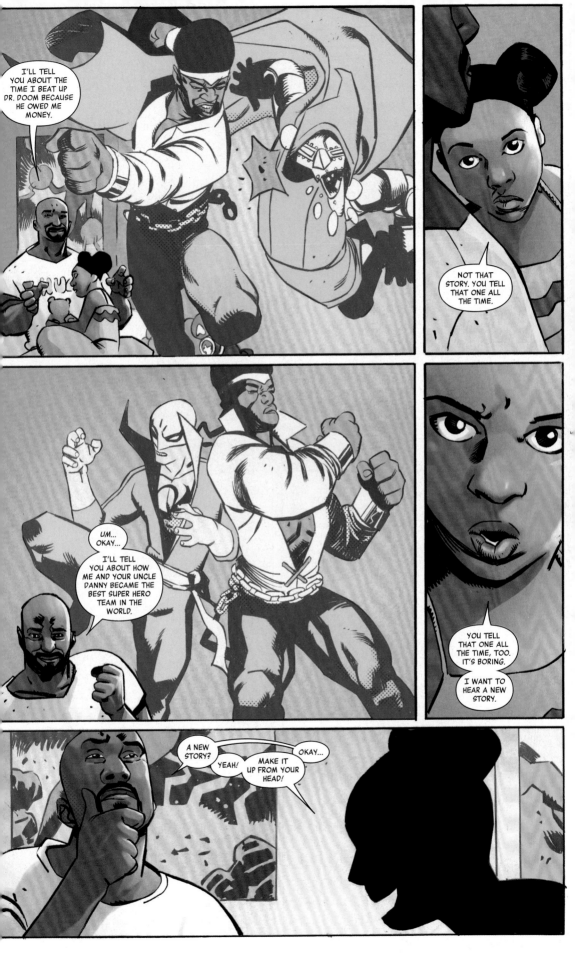

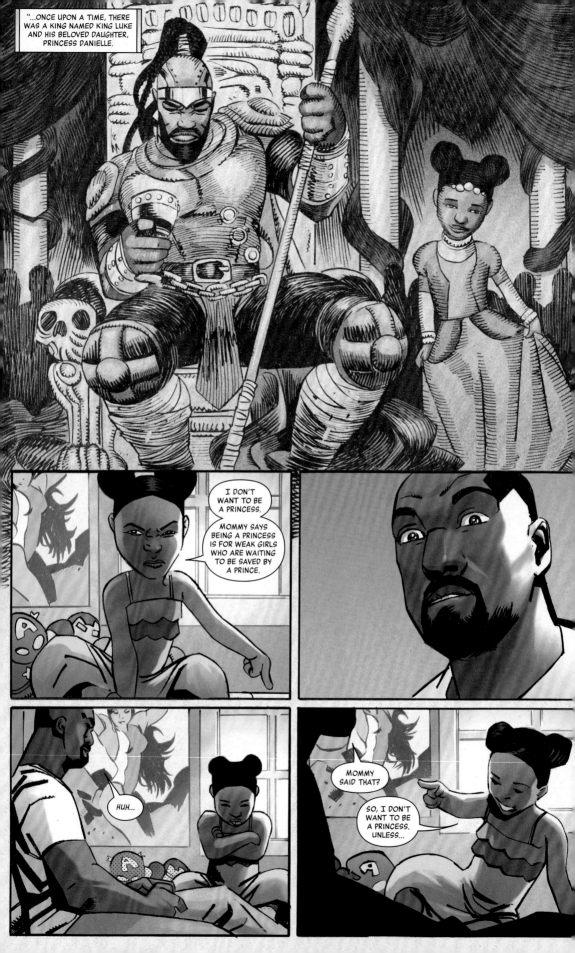

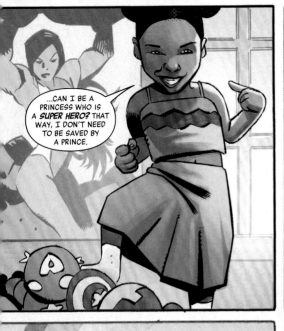
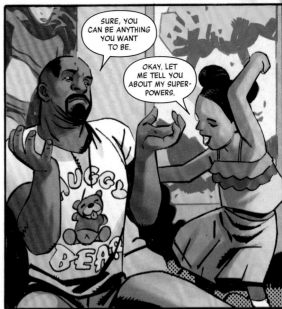
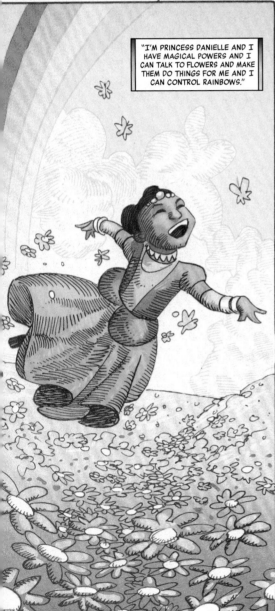
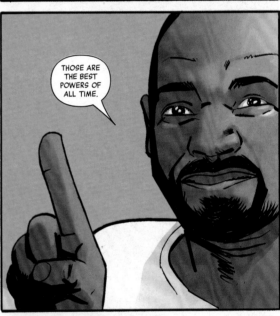
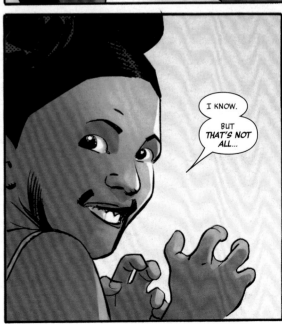

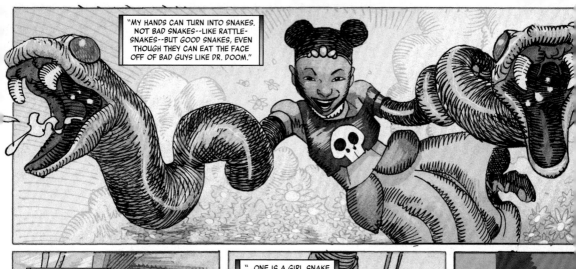

"MY HANDS CAN TURN INTO SNAKES. NOT BAD SNAKES--LIKE RATTLE-SNAKES--BUT GOOD SNAKES, EVEN THOUGH THEY CAN EAT THE FACE OFF OF BAD GUYS LIKE DR. DOOM."

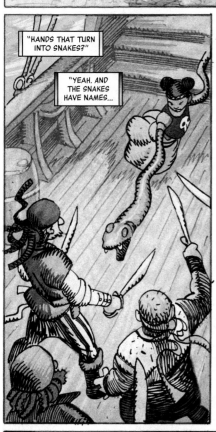

"HANDS THAT TURN INTO SNAKES?"

"YEAH. AND THE SNAKES HAVE NAMES..."

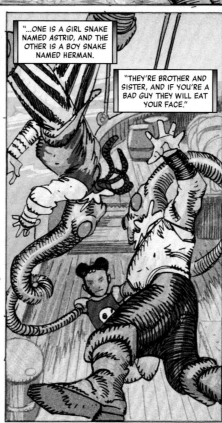

"...ONE IS A GIRL SNAKE NAMED ASTRID, AND THE OTHER IS A BOY SNAKE NAMED HERMAN.

"THEY'RE BROTHER AND SISTER, AND IF YOU'RE A BAD GUY THEY WILL EAT YOUR FACE."

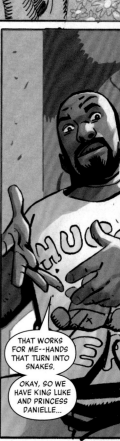

THAT WORKS FOR ME--HANDS THAT TURN INTO SNAKES.

OKAY, SO WE HAVE KING LUKE AND PRINCESS DANIELLE...

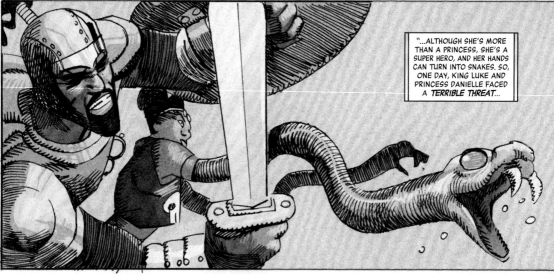

"...ALTHOUGH SHE'S MORE THAN A PRINCESS, SHE'S A SUPER HERO, AND HER HANDS CAN TURN INTO SNAKES. SO, ONE DAY, KING LUKE AND PRINCESS DANIELLE FACED A *TERRIBLE THREAT*..."

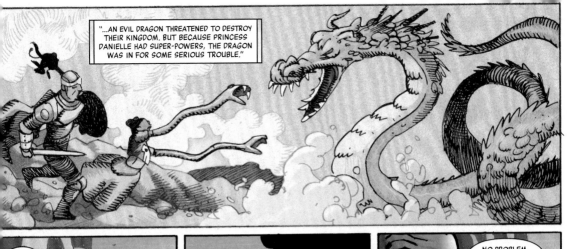

"...AN EVIL DRAGON THREATENED TO DESTROY THEIR KINGDOM. BUT BECAUSE PRINCESS DANIELLE HAD SUPER-POWERS, THE DRAGON WAS IN FOR SOME SERIOUS TROUBLE."

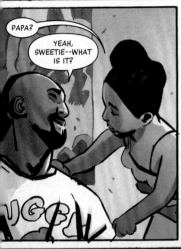

PAPA?

YEAH, SWEETIE--WHAT IS IT?

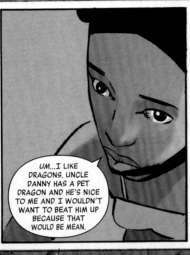

UM...I LIKE DRAGONS. UNCLE DANNY HAS A PET DRAGON AND HE'S NICE TO ME AND I WOULDN'T WANT TO BEAT HIM UP BECAUSE THAT WOULD BE MEAN.

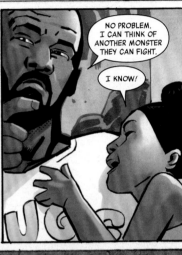

NO PROBLEM. I CAN THINK OF ANOTHER MONSTER THEY CAN FIGHT.

I KNOW!

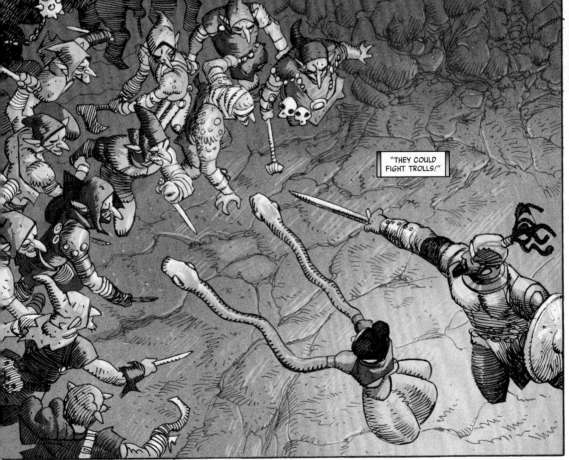

"THEY COULD FIGHT TROLLS!"

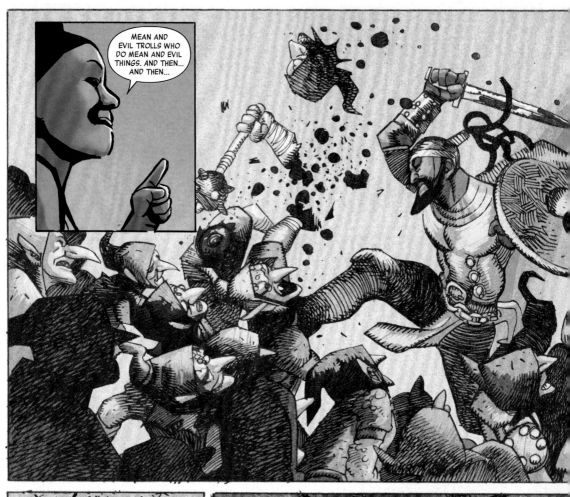

MEAN AND EVIL TROLLS WHO DO MEAN AND EVIL THINGS. AND THEN... AND THEN...

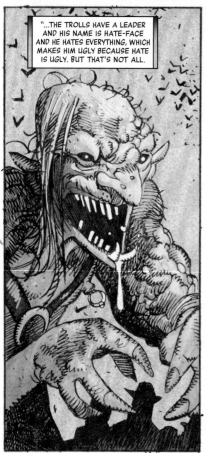

"...THE TROLLS HAVE A LEADER AND HIS NAME IS HATE-FACE AND HE HATES EVERYTHING, WHICH MAKES HIM UGLY BECAUSE HATE IS UGLY. BUT THAT'S NOT ALL.

"HATE-FACE HAS PET BIRDS, BUT THEY ARE MONSTER BIRDS CALLED YUCK-BIRDS AND THE YUCK-BIRDS POOP ON EVERYTHING."

"...AND THEN...KING LUKE AND PRINCESS DANIELLE FIGHT THE EVIL AND MEAN TROLLS. AND THEN KING LUKE SMOOSHES THEM. AND THEN... PRINCESS DANIELLE EATS THEIR FACES WITH HER SNAKE HANDS."

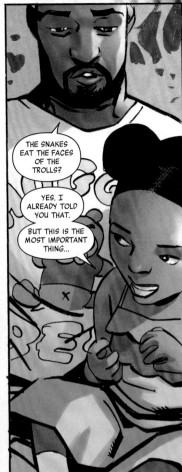

THE SNAKES EAT THE FACES OF THE TROLLS?

YES. I ALREADY TOLD YOU THAT.

BUT THIS IS THE MOST IMPORTANT THING...

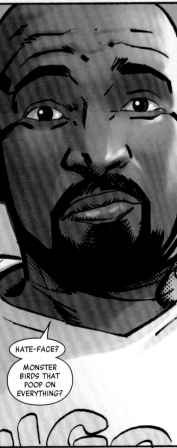

HATE-FACE?

MONSTER BIRDS THAT POOP ON EVERYTHING?

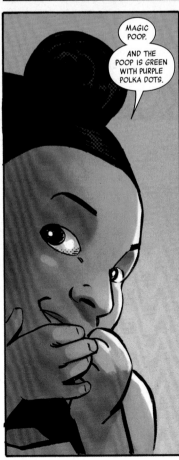

MAGIC POOP.

AND THE POOP IS GREEN WITH PURPLE POLKA DOTS.

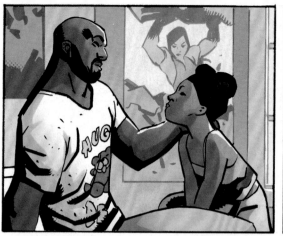

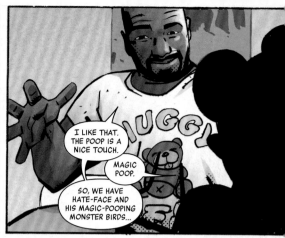

I LIKE THAT. THE POOP IS A NICE TOUCH.

MAGIC POOP.

SO, WE HAVE HATE-FACE AND HIS MAGIC-POOPING MONSTER BIRDS...

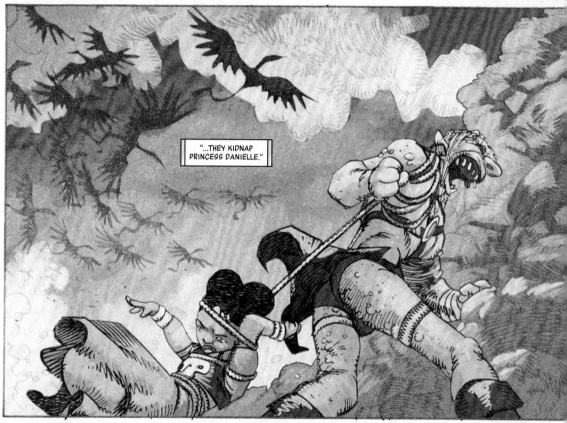

"...THEY KIDNAP PRINCESS DANIELLE."

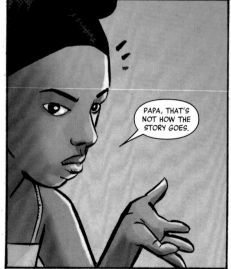

PAPA, THAT'S NOT HOW THE STORY GOES.

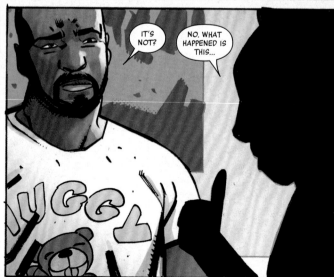

IT'S NOT?

NO. WHAT HAPPENED IS THIS...

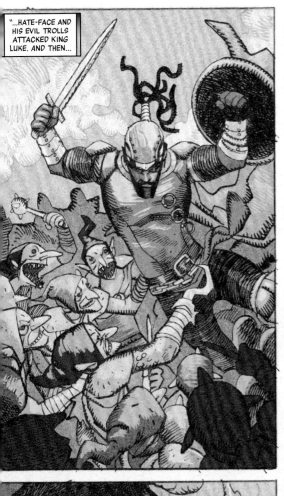

"...HATE-FACE AND HIS EVIL TROLLS ATTACKED KING LUKE. AND THEN...

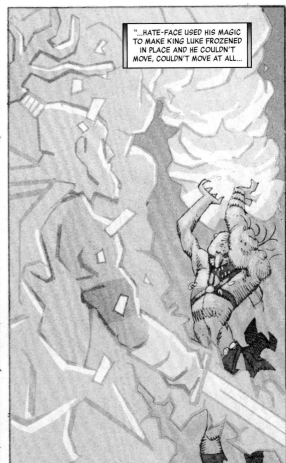

"...HATE-FACE USED HIS MAGIC TO MAKE KING LUKE FROZENED IN PLACE AND HE COULDN'T MOVE, COULDN'T MOVE AT ALL...

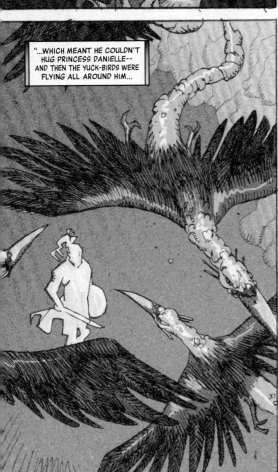

"...WHICH MEANT HE COULDN'T HUG PRINCESS DANIELLE-- AND THEN THE YUCK-BIRDS WERE FLYING ALL AROUND HIM...

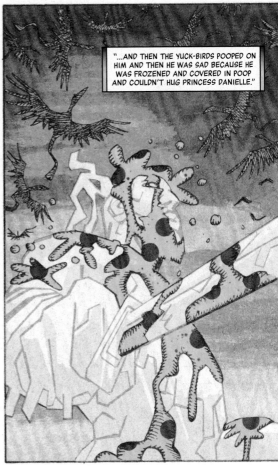

"...AND THEN THE YUCK-BIRDS POOPED ON HIM AND THEN HE WAS SAD BECAUSE HE WAS FROZENED AND COVERED IN POOP AND COULDN'T HUG PRINCESS DANIELLE."

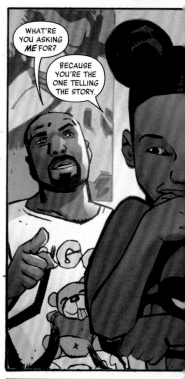

SWEET CHRISTMAS. COVERED IN POOP *AND* CAN'T HUG PRINCESS DANIELLE? THAT'S A FATE WORSE THAN DEATH.

I KNOW. WHAT HAPPENS NEXT?

WHAT'RE YOU ASKING *ME* FOR?

BECAUSE YOU'RE THE ONE TELLING THE STORY.

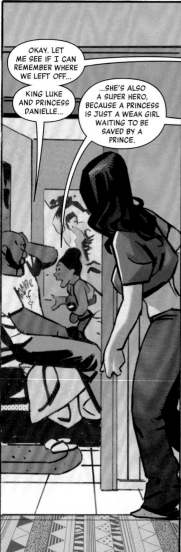

OKAY. LET ME SEE IF I CAN REMEMBER WHERE WE LEFT OFF...

KING LUKE AND PRINCESS DANIELLE...

...SHE'S ALSO A SUPER HERO, BECAUSE A PRINCESS IS JUST A WEAK GIRL WAITING TO BE SAVED BY A PRINCE.

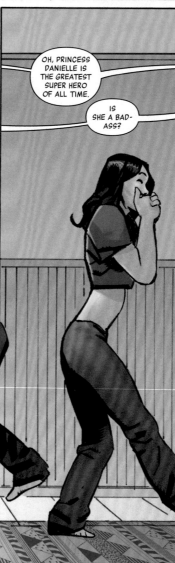

OH, PRINCESS DANIELLE IS THE GREATEST SUPER HERO OF ALL TIME.

IS SHE A BAD-ASS?

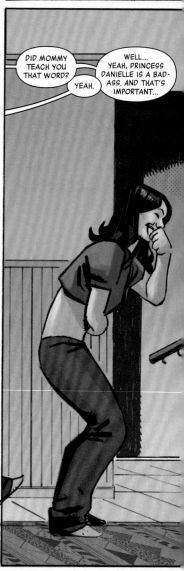

DID MOMMY TEACH YOU THAT WORD?

YEAH.

WELL... YEAH, PRINCESS DANIELLE IS A BAD-ASS. AND THAT'S IMPORTANT...

"...BECAUSE KING LUKE WAS FROZEN IN PLACE BY HATE-FACE, WHICH MEANT THERE WAS NO ONE LEFT TO PROTECT THE KINGDOM.

"ONE BY ONE, THE GREATEST HEROES OF THE KINGDOM WERE OVERPOWERED BY HATE-FACE.

"EVERYONE WHO TRIED TO STOP HATE-FACE FELL VICTIM TO HIS SINISTER PLAN.

"WITH ALL THE HEROES FROZEN IN PLACE, NOTHING COULD STOP HATE-FACE."

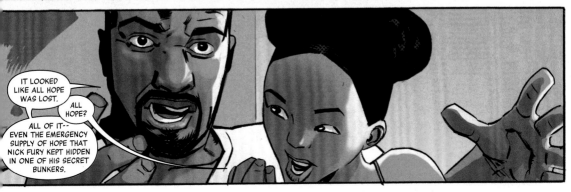

IT LOOKED LIKE ALL HOPE WAS LOST.

ALL HOPE?

ALL OF IT-- EVEN THE EMERGENCY SUPPLY OF HOPE THAT NICK FURY KEPT HIDDEN IN ONE OF HIS SECRET BUNKERS.

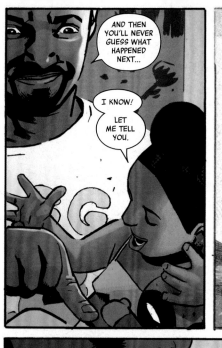

AND THEN YOU'LL NEVER GUESS WHAT HAPPENED NEXT...

I KNOW! LET ME TELL YOU.

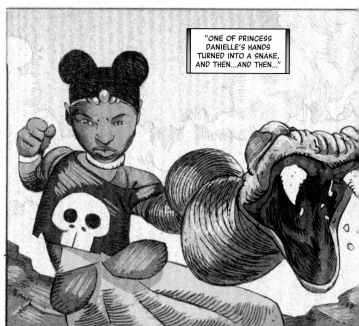

"ONE OF PRINCESS DANIELLE'S HANDS TURNED INTO A SNAKE, AND THEN...AND THEN..."

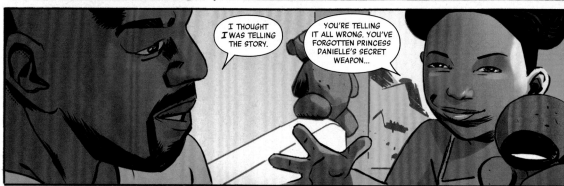

I THOUGHT *I* WAS TELLING THE STORY.

YOU'RE TELLING IT ALL WRONG. YOU'VE FORGOTTEN PRINCESS DANIELLE'S SECRET WEAPON...

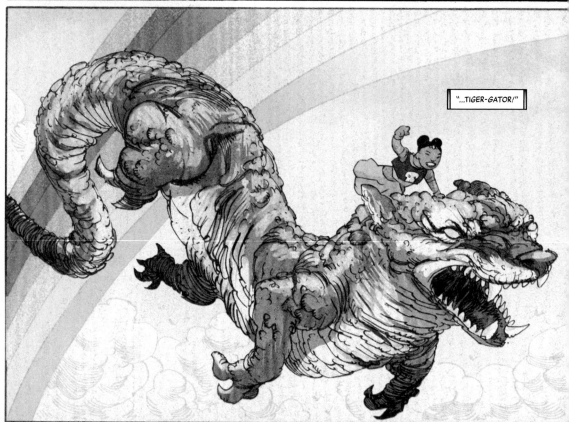

"...TIGER-GATOR!"

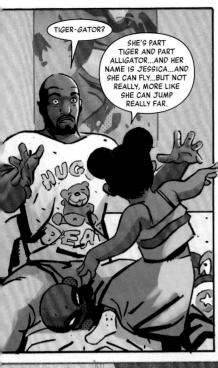

TIGER-GATOR?

SHE'S PART TIGER AND PART ALLIGATOR...AND HER NAME IS JESSICA...AND SHE CAN FLY...BUT NOT REALLY, MORE LIKE SHE CAN JUMP REALLY FAR.

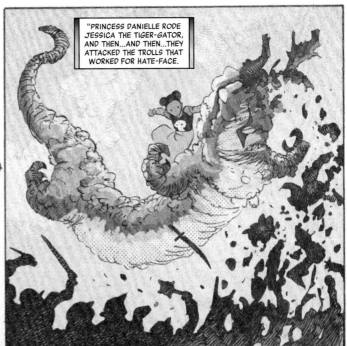

"PRINCESS DANIELLE RODE JESSICA THE TIGER-GATOR, AND THEN...AND THEN...THEY ATTACKED THE TROLLS THAT WORKED FOR HATE-FACE.

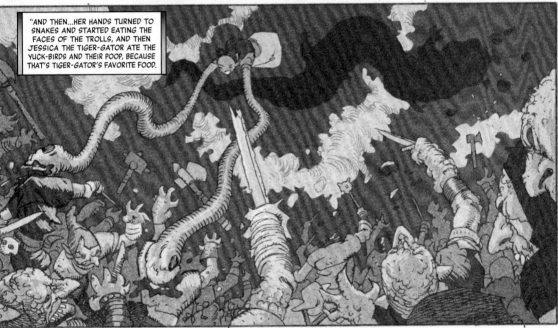

"AND THEN...HER HANDS TURNED TO SNAKES AND STARTED EATING THE FACES OF THE TROLLS, AND THEN JESSICA THE TIGER-GATOR ATE THE YUCK-BIRDS AND THEIR POOP, BECAUSE THAT'S TIGER-GATOR'S FAVORITE FOOD.

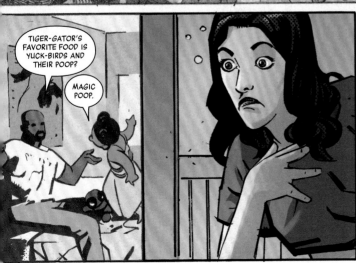

TIGER-GATOR'S FAVORITE FOOD IS YUCK-BIRDS AND THEIR POOP?

MAGIC POOP.

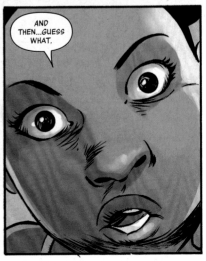

AND THEN...GUESS WHAT.

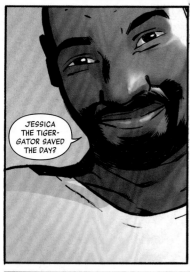

JESSICA THE TIGER-GATOR SAVED THE DAY?

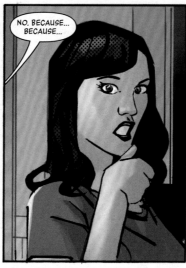

NO. BECAUSE... BECAUSE...

...IT WAS THE MAGIC POOP.

IT *DID* *SOMETHING* TO JESSICA THE TIGER-GATOR...

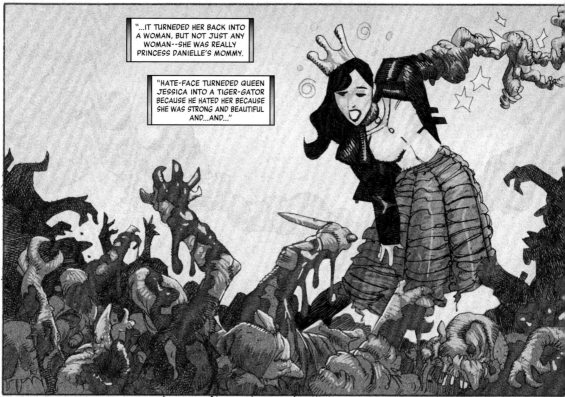

"...IT TURNEDED HER BACK INTO A WOMAN, BUT NOT JUST ANY WOMAN--SHE WAS REALLY PRINCESS DANIELLE'S MOMMY.

"HATE-FACE TURNEDED QUEEN JESSICA INTO A TIGER-GATOR BECAUSE HE HATED HER BECAUSE SHE WAS STRONG AND BEAUTIFUL AND...AND..."

WHAT'S THE MATTER, SWEETIE? YOU LOOK UPSET.

THIS PART OF THE STORY MAKES ME SAD.

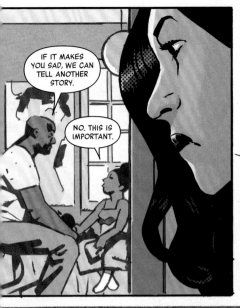

IF IT MAKES YOU SAD, WE CAN TELL ANOTHER STORY.

NO. THIS IS IMPORTANT.

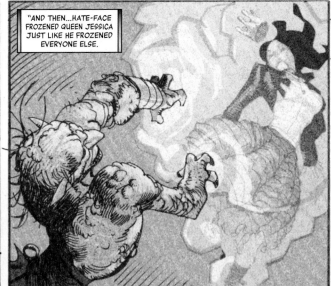

"AND THEN...HATE-FACE FROZENED QUEEN JESSICA JUST LIKE HE FROZENED EVERYONE ELSE.

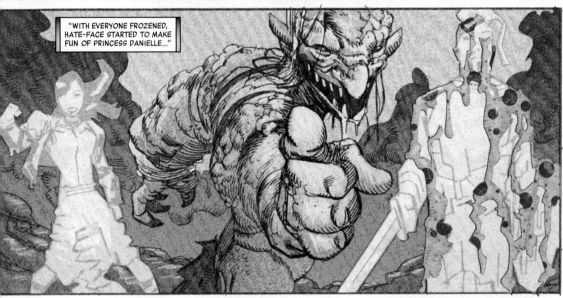

"WITH EVERYONE FROZENED, HATE-FACE STARTED TO MAKE FUN OF PRINCESS DANIELLE..."

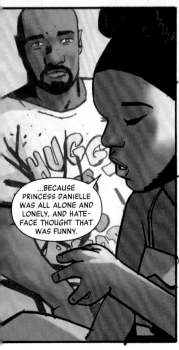

...BECAUSE PRINCESS DANIELLE WAS ALL ALONE AND LONELY, AND HATE-FACE THOUGHT THAT WAS FUNNY.

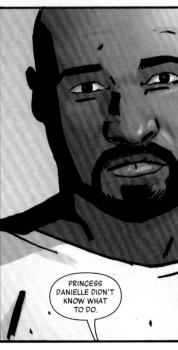

PRINCESS DANIELLE DIDN'T KNOW WHAT TO DO.

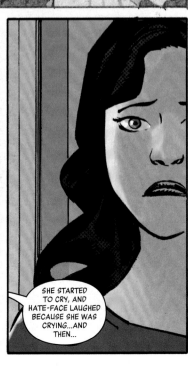

SHE STARTED TO CRY, AND HATE-FACE LAUGHED BECAUSE SHE WAS CRYING...AND THEN...

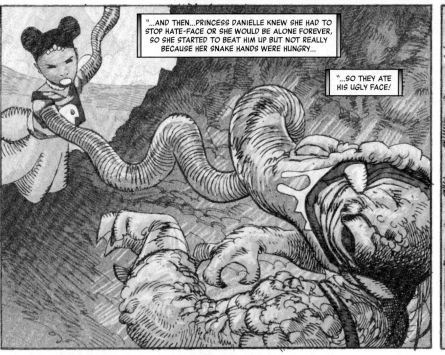

"...AND THEN...PRINCESS DANIELLE KNEW SHE HAD TO STOP HATE-FACE OR SHE WOULD BE ALONE FOREVER, SO SHE STARTED TO BEAT HIM UP BUT NOT REALLY BECAUSE HER SNAKE HANDS WERE HUNGRY...

"...SO THEY ATE HIS UGLY FACE!

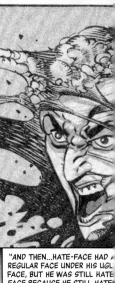

"AND THEN...HATE-FACE HAD A REGULAR FACE UNDER HIS UGL FACE, BUT HE WAS STILL HATE FACE BECAUSE HE STILL HATE EVERYTHING EVEN THOUGH HIS FACE WAS NORMAL.

"IT WAS VERY SAD.

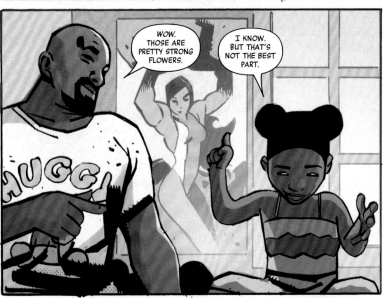

WOW. THOSE ARE PRETTY STRONG FLOWERS.

I KNOW. BUT THAT'S NOT THE BEST PART.

"THE BEST PART IS THAT PRINCESS DANIELLE USED HER MAGIC POWERS TO UNFROZENED KING LUKE AND QUEEN JESSICA.

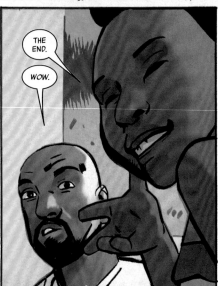

THE END.

WOW.

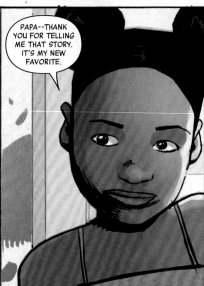

PAPA--THANK YOU FOR TELLING ME THAT STORY. IT'S MY NEW FAVORITE.

WELL, YOU KNOW SOMETHING, PEANUT--WE KINDA TOLD THAT STORY TOGETHER.

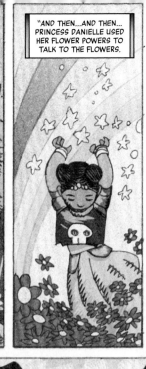

"AND THEN...AND THEN... PRINCESS DANIELLE USED HER FLOWER POWERS TO TALK TO THE FLOWERS."

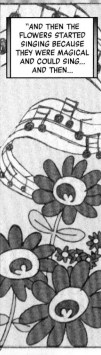

"AND THEN THE FLOWERS STARTED SINGING BECAUSE THEY WERE MAGICAL AND COULD SING... AND THEN..."

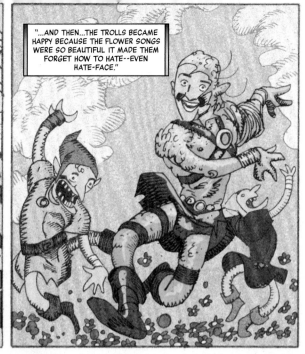

"...AND THEN...THE TROLLS BECAME HAPPY BECAUSE THE FLOWER SONGS WERE SO BEAUTIFUL IT MADE THEM FORGET HOW TO HATE--EVEN HATE-FACE."

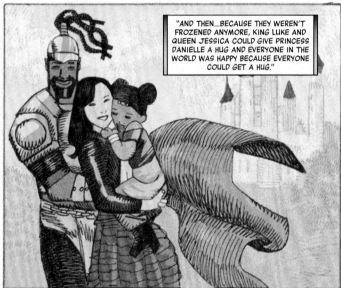

"AND THEN...BECAUSE THEY WEREN'T FROZENED ANYMORE, KING LUKE AND QUEEN JESSICA COULD GIVE PRINCESS DANIELLE A HUG AND EVERYONE IN THE WORLD WAS HAPPY BECAUSE EVERYONE COULD GET A HUG."

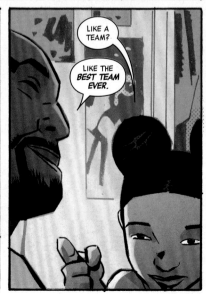

LIKE A TEAM?

LIKE THE **BEST TEAM EVER.**

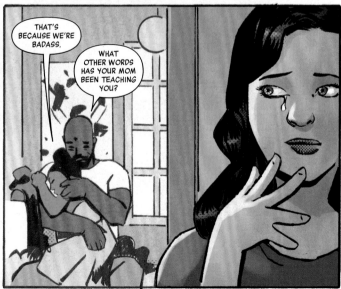

THAT'S BECAUSE WE'RE BADASS.

WHAT OTHER WORDS HAS YOUR MOM BEEN TEACHING YOU?

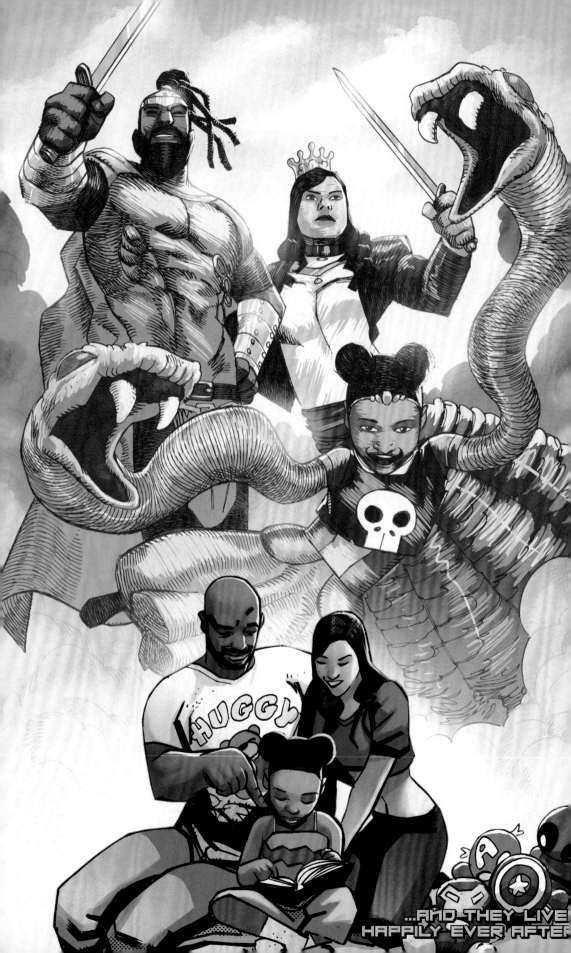

...AND THEY LIVE
HAPPILY EVER AFTER